THE BOSTON MARATHON

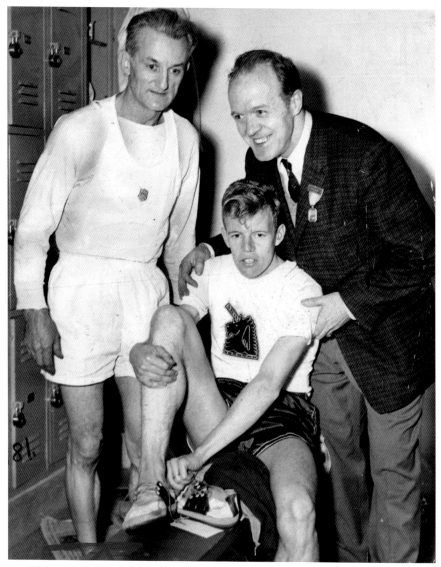

The trio of John A. Kelley (left), John J. Kelley (center), and John "Jock" Semple helped make the Boston Marathon the most honored race in the world. Not only did the two Kelleys rule the roads for nearly four decades, but Semple also literally ruled the Boston Marathon as both a competitor and volunteer race coordinator for nearly as long. (Courtesy of the Boston Herald.)

On the front cover: Please see page 105. (Courtesy of the Boston Herald.)

On the back cover: Aurele Vandendriessche (left,) the 1963 Boston Marathon champion, shares a post-race toast with runner-up John J. Kelley. (Courtesy of the Boston Herald.)

Cover background: Please see page 44. (Courtesy of the Boston Herald.)

THE BOSTON MARATHON

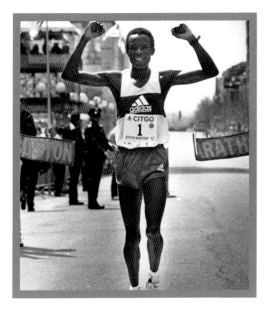

Richard A. Johnson and Robert Hamilton Johnson
Foreword by John J. Kelley

ARCADIA
PUBLISHING

Published by Arcadia Publishing
Charleston, South Carolina

Printed in the United States of America

Library of Congress Control Number: 2008935747

For all general information contact Arcadia Publishing at:
Telephone 843-853-2070
Fax 843-853-0044
E-mail sales@arcadiapublishing.com
For customer service and orders:
Toll-Free 1-888-313-2665

Visit us on the Internet at www.arcadiapublishing.com

To Mary and Lizzy, and in memory of Minna Flynn Johnson,

who made sure her son Richard got to the marathon starting line

in 1974 and who completed her 91-year marathon on Patriots' Day

in 2007. And to my fellow members of the 1973 Lawrence Academy

cross country team, the "Goon Squad," including Copey,

Sleepy Bill, Oaksey, Tom, Scotty, Mark, Johnny, Harry, Sampo,

Holmsey, and the late Tommy Warner.

CONTENTS

ACKNOWLEDGMENTS

The authors are grateful to the following people for their support and assistance with this project. First and foremost are the board of governors of the Boston Athletic Association, as well as association's executive director Guy Morse, marketing and communications director Jack Fleming, and vice president Gloria Ratti. All went above and beyond in their support of this book. We are also grateful to Tiffany Frary and her team at Arcadia, Frederick Lewis, Rick Cevy, John McGrath, Stan Grossfeld, Al Thibeault of the Boston Herald Library, Boston Herald photo editor Jim Mahoney, Sports Museum executive director Rusty Sullivan, the Boston Globe Library, Aaron Schmidt and the print department of the Boston Public Library, Running Past, and the late John "Jock" Semple, Will Cloney, John A. Kelley, and Jerry Nason, whose spirit helped inspire this book.

We are especially indebted to historian extraordinaire Tom Derderian for his definitive history of the Boston Marathon, which served as a touchstone and indispensable resource for this work. Derderian's book is a masterpiece that belongs in the library of any student of running, as well as that of anyone who has run this race of races.

FOREWORD

The best I can offer possibly by way of introducing my comparison of yesterday's Boston Marathon with today's is that I can identify with Rip Van Winkle. Remember Washington Irving's lovably feckless character who trudged off a Catskill mountainside following a 20-year snooze to a home village he could barely recognize?

One good bridge from then to now might be our shared perception of what Boston has become since the torch was passed from the hands of its original working-class heroes to those of its present elite bearers. The torch image may unfairly telescope time though, for the marathon's growth and demographic shift did not happen overnight.

When I entered the world on the eve of 1931, the great runner Clarence DeMar was 42 years old and had won his seventh Boston Marathon (a record still unbroken) the previous April. He continued to race through his remaining three decades of life.

The 1930 Boston Marathon listed 216 entrants—all males. From its 1897 inaugural draw of 18 entrants, producing 10 finishers, the event's fields climbed in numbers to between 70 and nearly 300 during DeMar's reign, which began in 1911.

Here, it should be emphasized that DeMar's—as well as every other marathoner's of his age—was a pure athletic labor of love. There was never a money prize attached to the Boston Athletic Association marathon until 1986. Under the iron rule of an aristocratic old guard, runners of the period forfeited their right to compete if found guilty of accepting payment.

From its beginning, the marathon exerted a hearty, if sometimes ghoulishly tinged, appeal. Legend has it that fifth century BC soldier/courier Pheidippides died in the instant of his glorious announcement. So it was to be expected that many among the new American marathon's long gallery of spectators believed they might witness a fatal collapse, and that the tragic happening was averted was perhaps a tribute to the hardiness of the race's early practitioners.

Who were those protagonists who annually came to celebrate the heroism of a man who might or might not have actually lived two-and-a-half millennia before them? Well, 1897 winner James J. McDermott's occupation was unknown. Lawrence Brignolia (1899) was a blacksmith. Timothy Ford (1906) was a plumber's apprentice. Henri Renaud (1909) was a mill hand. Bill Kennedy (1917), nicknamed "Bricklayer Bill," was jobless in the year of his triumph and, as the story goes, rode a freight car from New York to Boston where he slept on a "Southie" pool table the night before the race.

My heroes of the Boston Athletic Association's 1930s golden age were but marginally better placed. Les Pawson ran himself into a Pawtucket, Rhode Island, playground supervisor's job. John A. Kelley's 1935 employment was as a florist's assistant, but by the time of his second win a decade later, he had risen to "Pfc., U.S. Army." Ellison "Tarzan" Brown was an in-and-out-of-work stonemason, and his family's well being was not quite assured by their Ashaway, Rhode Island, Narragansett Tribal Reservation entitlement.

Compared with his contemporaries, DeMar was a towering exemplar of the great American work ethic—typesetter, family farmer, teacher, Boy Scout leader, author, and lecturer. He used his position to champion the rights of his fellow amateur athletes to obtain adequate per-diem allowances when they were members of international teams and to bring United States marathon courses into line with the 26.2-mile Olympic standard.

My generation became the bridge between those working-class heroes and the multitudes to follow. We were the first of the college-trained marathoners. We occupied two decades—from Ted Vogel (Tufts University) in 1948 to Amby Burfoot (Wesleyan University) in 1968. We boasted track-style speed. We believed we had a mission—to supplant the shufflers of the marathon's first half-century.

Like those blue-collar guys, however, we too toiled to support our running lives. I enjoyed a Boston University "working scholarship," which offered a limited choice of necessary part-time campus jobs, including running an elevator, cooking or washing dishes in my dormitory, busing in the Boston University Commons, and—impossible to picture—acting as a pool lifeguard.

Thus our marathon aspirants' days unfolded. The great shift awaited Frank Shorter's Munich victory. As yet there were no women and no "Share the Road with a Runner" stickers.

To expand my waking hours, I took to training alone along the Charles River Esplanade at first light. I seldom met a fellow pedestrian in the course of my treks from the Back Bay Metropolitan District Commission station to Harvard University's Elliott Bridge and back.

One April morning, though, I found myself jogging to a stop a few yards from a pair in process of finishing their own workout. The younger of the two looked to be about my age and stood about as tall. Sweat from his exercising still beaded his face.

His older friend stood a few feet off. He held a stopwatch in one hand and a towel in the other. As his pupil began a stretching routine, he fixed me with his eyes. "So what weight you fight?" he asked. "I don't fight," I answered. "Jeez, that's good news!" he said. "All that running. You gotta be in top form. I watched you go by twice." I laughed. He still could not put it together. "So you don't fight, what do you do?" "I'm training for the marathon," I said. He scratched at his neck. "Cripes, if you don't mind me asking, what the hell is the marathon?" It was the spring of 1956, too soon, maybe, to try to explain.

John J. Kelley
1957 B.A.A. Marathon Champion

INTRODUCTION

Since 1897, the Patriots' Day holiday in Massachusetts has been celebrated with the running of the Boston Marathon, the world's most honored road race and the oldest continually run marathon in America. Not only has the race served as the showcase for such talents like Clarence DeMar, Ellison "Tarzan" Brown, Gerard Cote, Joan Benoit Samuelson, Jean Driscoll, Ron Hill, Bill Rodgers, Cosmas Ndeti, Fatuma Roba, and two remarkable men named John Kelley, but the race has also become the mecca for every runner.

Imagine being allowed to golf on the Masters course on the same day Tiger Woods teed up for the championship or getting to bat at Fenway Park on the day of a World Series game, and it comes close to duplicating the sensation experienced by those runners fortunate enough to make it to Hopkinton on Patriots' Day.

Long before the running boom, the race established itself as the showcase for numerous working-class heroes bound by the strict amateur code that existed until the 1980s, which only allowed runners to receive their medals/trophies, a bowl of beef stew, and a pat on the back.

Among this rare breed were men like "Bricklayer Bill" Kennedy, who, short of cash following his train trip from New York, spent the night prior to his 1917 Boston Marathon victory sleeping on a billiard table. In later years, schoolteacher and 1957 champion John J. Kelley, considered by many to be the most important marathoner in American running history, had to request a day off from school in Connecticut to make the trip to Boston.

DeMar, a seven-time champion, may have been the ultimate working-class hero, as he departed the medal ceremony and jogged his race warm down on his way to the *Boston Herald*, where he worked as a typesetter. Legend has it that on several occasions, DeMar was granted the privilege of setting the bold type proclaiming his victory in one of the many extra editions of the newspaper printed on Patriots' Day. Such was the tale of just one of the many champions whose inspiring stories have helped make Boston the greatest marathon of them all.

Other compelling features of the race are its hilly topography and unpredictable climate. The course starts with several deceptively fast downhill stretches and leads to a series of hills, collectively nicknamed "Heartbreak Hill" by sportswriter Jerry Nason in the 1930s. These hills rise to greet runners just as their glycogen supplies are dwindling and the sight of Boston's skyscrapers tempt them to push the pace from the 17th to the 20th miles. Most races are won and lost on this undulating ribbon of roadway.

Perhaps the most challenging segment of the race is the pothole pocked downhill run from Newton through Brookline. It is here that the crowds become increasingly dense and loud, and the urge to surge has cost many runners a chance at a laurel wreath or personal best as calves cramp and thighs tighten after miles of pounding.

Runners must also brace for conditions as apt to bring snow and hail as the oppressive heat that marked the infamous "Inferno" of 1909 or the "Run for the Hoses" of 1976. If runners

are lucky, they get the perfect conditions and tailwind that helped Bill Rodgers charge to an American and course record in his first Boston victory in 1975.

Over the years, the Boston Marathon has also served as the tableau for a multitude of causes and social issues. In 1946, on the occasion of the race's 50th anniversary, Stylianos Kyriakides's dramatic victory allowed him to undertake nothing less than a one-man Marshall Plan for his war-stricken homeland of Greece. After traveling across America to raise funds, he was greeted by over a million Athenians upon his triumphant return home slightly more than a month after winning the race of a lifetime.

Likewise, in the late 1960s, marathon pioneers Roberta Gibb and Katherine Switzer proved to race officials and the public alike that the 26-mile trek was as suited to women as well as men. They helped lead a movement that included the likes of Billie Jean King and the women's rowing team from Yale University, which created the climate where both Title IX and the expanded women's Olympic program were born.

In the same spirit, wheelchair competitors such as Eugene Roberts, Bob Hall, Jean Driscoll, Jim Knaub, Franz Nietlispach, Candace Cable-Brooks, and many others, along with the incredible father-son team of Dick and Rick Hoyt, have proven that physical challenges are just one more fact of the race to be conquered on the road to Boston.

It is our hope that we have captured the spirit of the unmatched history of the Boston Marathon within these pages. We have tried to locate as many hitherto unpublished photographs as possible while calling in a multitude of favors along the way. If anything, we hope this book will illuminate the heritage of one of the sporting world's last great democratic events. We also hope it will inspire runners to consider adding their names to the roster of those who have run in the footsteps of the immortals.

Richard A. Johnson
Robert Hamilton Johnson

THE 1890S TO 1930

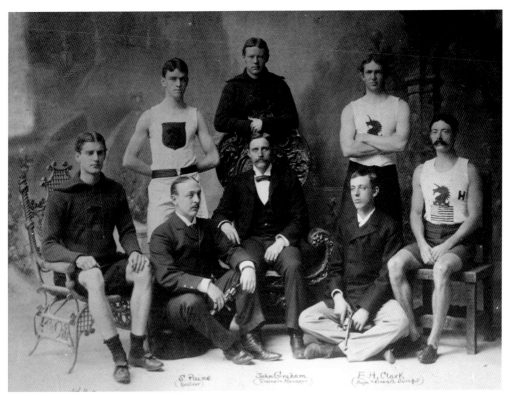

The father of the Boston Marathon was former U.S. Olympic team coach John Graham (seated at center) here posed with the Boston Athletic Association (B.A.A.) team members who took part in the first modern Olympics in Athens in 1896. From left to right are (first row) W. W. Hoyt, S. Paine, J. B. Paine, and Arthur Blake; (second row) Thomas E. Burke, T. P. Curtis, and Ellery Clark. Graham was inspired by the Olympic marathon to bring the event to Boston. (Courtesy of the Boston Public Library.)

THE START

A SPURT

Lithographer John J. McDermott of New York arrived at the first Boston Marathon in 1897 as the first runner to have won a full marathon held on American soil, a race sponsored by the Knickerbocker AC from Stamford, Connecticut, to New York City in 1896. McDermott repeated his feat at Boston while besting a field of 15 starters to win in a world record time of 2:55:10. (Courtesy of the Boston Globe.)

Long before fast food sponsor dollars would have overwhelmed him, 22-year-old Boston College student Ronald J. MacDonald bested a field of 25 runners to capture the second Boston Marathon in 2:42. (Courtesy of the Boston Globe.)

GLOBE EXTRA!
5 O'CLOCK.

MARATHON WINNER.

Swift Ronald McDonald of the Cambridge Gymnasium.

All Records Smashed With the Figures Standing at 2 Hours 42 Minutes—O'Connor of the Pastime A. C., New York, Leader Much of the Way, but Was Unequal at Finish to Fearful Pace Set by the Winner.

The 17-man field for the 1899 Boston Marathon races through Natick. Leading the 11 finishers in a time of 2:54:38 was Cambridge blacksmith Larry Brignolia, who was also an accomplished sculler. (Courtesy of the Boston Public Library.)

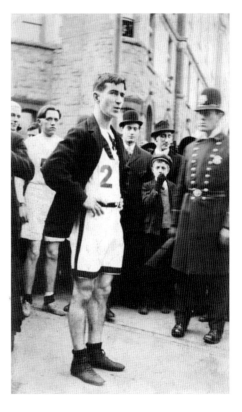

Sam Mellor of New York's Hollywood Inn Athletic Club and Mohawk Athletic Club was one of the early stars of the Boston Marathon. Not only did he capture the 1902 race in a time of 2:43:12, but he also enjoyed top-10 finishes in 1903 (second place, 2:47:13), 1901 (third place, 2:44:34), 1904 (sixth place, 2:44:43), and 1905 (fifth place, 3:00:53). (Courtesy of the Boston Public Library.)

Lorden Won in 2:41:29⅘.

Sick at Start, Ran Himself Well.

Game Caffrey Pushed Till Collapse.

Mellor Killed His Own Chances.

Did It in Killing the Canadian.

Near 200,000 Saw the Race or Finish.

THE WINNERS AND TIMES:

In 1903, John C. Lorden of Cambridgeport ignored a doctor's warning that he not run the race and instead beat defending champion Sam Mellor by nearly six minutes, with a time of 2:41:29. (Courtesy of the Boston Globe.)

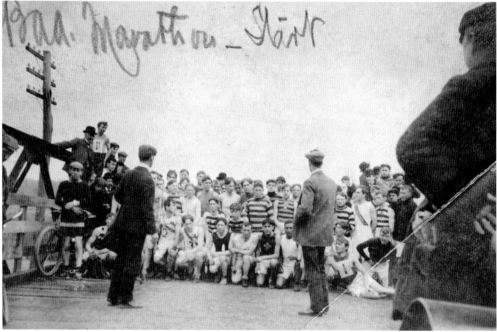

The starting field of 67 runners awaits the start of the 1904 race in Ashland. The top runners were soon assisted by handlers and coaches who followed their athletes on bicycles and automobiles. (Courtesy of the Boston Athletic Association.)

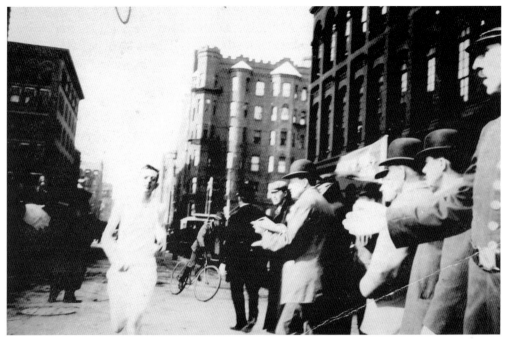

An unidentified runner crosses the finish line of the 1904 race. This is one of a series of rare marathon photographs recently donated to the B.A.A. (Courtesy of the Boston Athletic Association.)

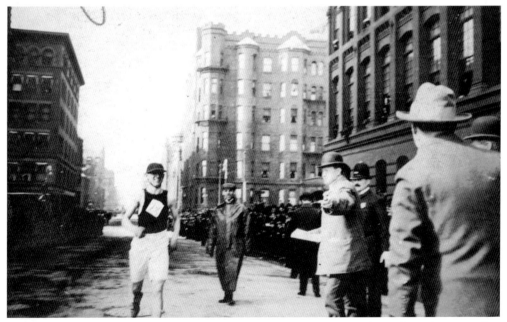

This unidentified finisher of the 1904 race was joined in Boston's Back Bay by at least 40 other competitors as Michael Spring of New York's Pastime Athletic Club won in a time of 2:38:04. (Courtesy of the Boston Athletic Association.)

LORZ FIRST HOME OF MARATHON RUNNERS

Immense Crowds Cheer Splendid Victory Of the Game New Yorker.

Fred Lorz was one of the most bizarre characters in distance running history. After dropping out of the 1904 Olympic marathon in St. Louis, he jumped out of the first aid car and ran into the Olympic stadium to the cheers of spectators who thought he had won the race. Officials grabbed him before Pres. Theodore Roosevelt's daughter Alice Longworth could drape a gold medal around his neck. In 1905, he needed no ruses to capture the Boston Marathon winner's medal as he bested a field of 78 in a time of 2:38:25. (Courtesy of the Boston Globe.)

GLOBE LATEST!
7 30 O'CLOCK

FORD WINS THE MARATHON

Cambridge Runner's Great Victory.

Completes 25 Mile Run In 2 Hours 45 Min.

Kneeland of Roxbury Finishes Second After Leading for Greater Part of Way.

By 1906, Boston newspapers were giving the Boston Marathon substantial coverage, especially when local runners such as Tom Ford of Cambridge delivered the goods. This headline was included in an extra edition of the *Boston Evening Globe*. (Courtesy of the Boston Globe.)

Nineteen-year-old Tom Longboat traveled to Boston from the Onondaga Reserve of the Six Nations near Brantford, Ontario, in 1907 to capture the Boston Marathon in a course record-setting time of 2:24:24. During the first half of the race, the first 10 runners got separated from the field by a slow-moving freight train that crossed the course in Framingham and blocked the remaining 114 runners for nearly a minute and a half. (Courtesy of the Boston Public Library.)

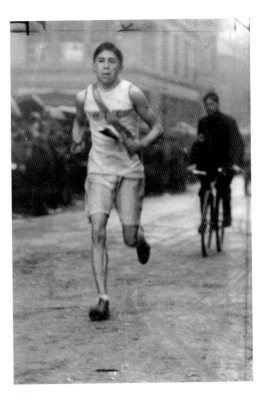

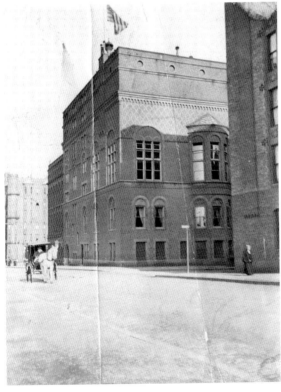

The B.A.A. clubhouse was built on Exeter Street in 1888, the same year that the Amateur Athletic Union was formed. Both organizations represented an old-money establishment bent on curtailing and eliminating much of the shady professionalism that marked early non-collegiate running events. The B.A.A. clubhouse featured a lavish dining room, poolroom, bowling alley, Turkish baths, and a swimming pool, among other amenities. (Courtesy of the Boston Public Library.)

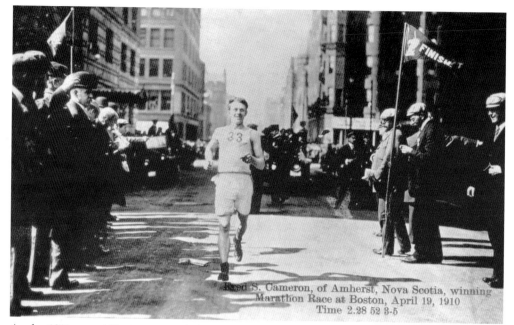

Fred S. Cameron, of Amherst, Nova Scotia, winning
Marathon Race at Boston, April 19, 1910
Time 2.28 52 3-5

At the 1910 race, 169 runners toed the start. Fred Cameron of Nova Scotia went on to win the race, aided by the misfortunes of the two favorites, Harry Jensen and Daniel Sheridan, who both dropped out. (Courtesy of Running Past.)

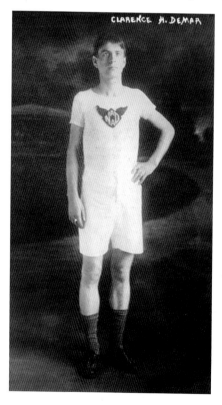

Clarence DeMar poses with his running outfit on. DeMar was a cross-country star in college at the University of Vermont and one of the first true students of distance running. He did not like coaches and preferred to educate himself on running through books. DeMar seriously studied for the race as well as trained intensely, logging 100-mile weeks. He won his first Boston Marathon in 1911, with a course record time of 2:21:39. (Courtesy of Running Past.)

THE 1890S TO 1930

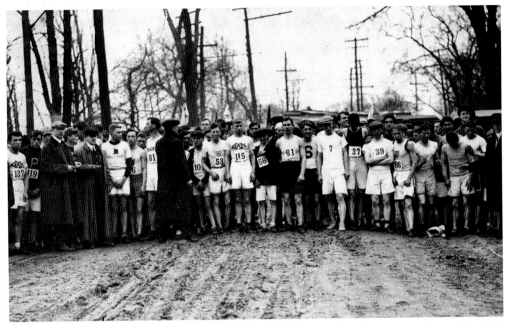

While being given instructions by race organizers, 123 men wait at the starting line of the 1912 marathon. The starting line on a muddy road among bare trees is far from today's start but might be argued by some to be a good symbol of the trials ahead of the runners before they reach Boston. (Courtesy of the Boston Public Library.)

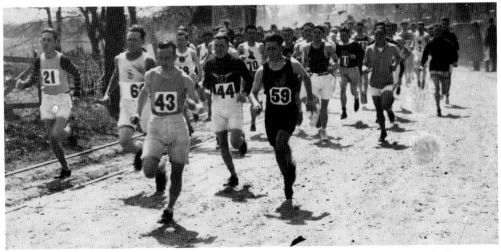

The runners break away from the start in 1916. John Brady (43) led the race of 58 at the beginning only to fade to 32nd place. Arthur Roth, not seen here, came on strong to win the race, and no one up front here finished in the top 15. (Courtesy of the Boston Public Library.)

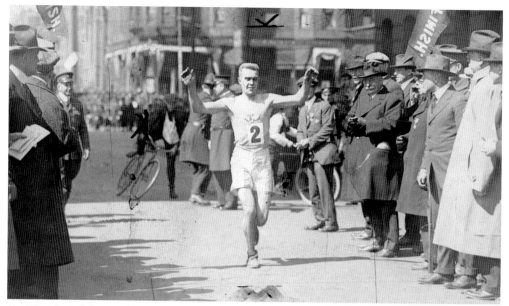

Carl Linder celebrates as he crosses the finish line in first place in the 1919 race. Linder and his running partner, Willie Wick, both from Quincy, Massachusetts, ran calmly to start the race, and both finished the final miles surging ahead to the top two spots, smiling the whole way. (Courtesy of the Boston Public Library.)

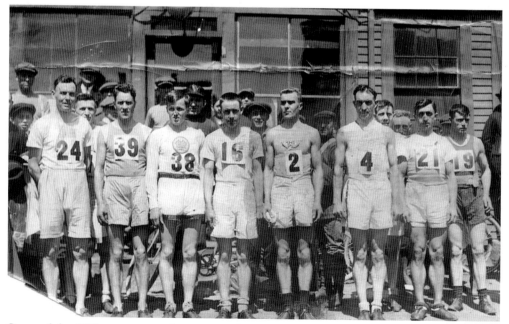

Some of the 1919 starters pose for a picture before the race. Linder (2), who won the race, has the look of a champion, with defined muscles, a strong jaw, and a fierce stare. He won not by crushing the competition but by enjoying the run and saving his energy for the important final miles. (Courtesy of the Boston Herald.)

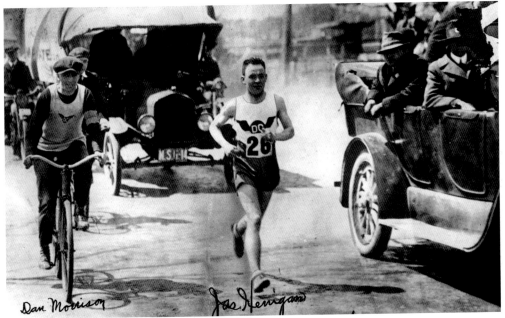

Jimmy Henigan leads the 1920 marathon. Henigan was a talented cross-country runner, but his talents were limited to races 10 miles and under, and he did not train adequately for the distance of a marathon. His speed carried him in front of the pack for the first 17 miles, but his lack of endurance ended any chance of winning. Henigan could not even hold on to finish the race, relinquishing the victory to Peter Trivoulidas. (Courtesy of the Boston Herald.)

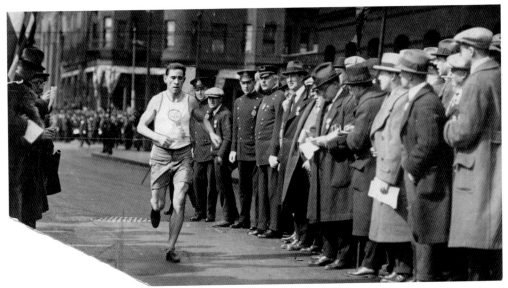

Frank Zuna crosses the finish line in a record-setting time of 2:18:57 in the 1921 marathon. Zuna, a veteran who served under Gen. John J. Pershing in both Mexico and France, was also a former army teammate of Clarence DeMar in the Inter-Allied Games of 1919. (Courtesy of the Boston Herald.)

The 1921 race proceeds through Newton in these snapshots. Newspaper accounts of the day commented on the large number of automobiles that followed the runners to Boston. (Courtesy of the Sallie Ramsden family.)

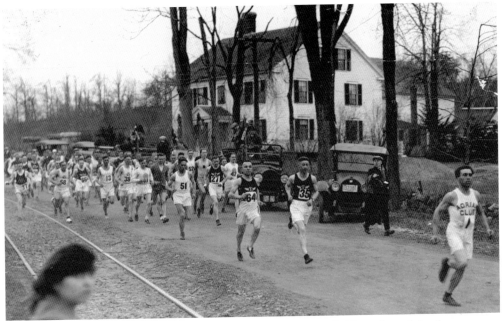

This pack of runners from the 1922 race charges through Natick. Note the rail for the streetcar. Marathon legend Clarence DeMar won his second Boston title with a course record of 2:18:10, while besting a field of 78 starters. (Courtesy of the Boston Public Library.)

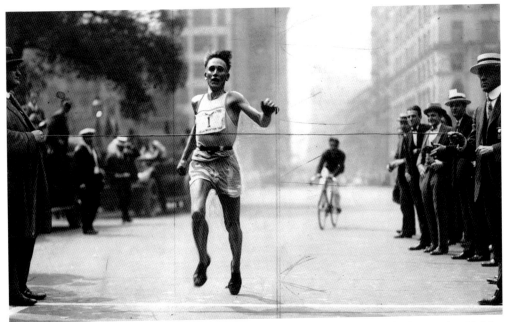

Finnish runner Willie Ritola, shown here in a race in New York City, finished second to DeMar in 1922, with a time of 2:21:44. Ritola later gained glory winning gold medals in both the 10,000 meters and steeplechase in the 1924 Olympics and the 5,000 meters in the 1928 Olympics. (Courtesy of the Boston Herald.)

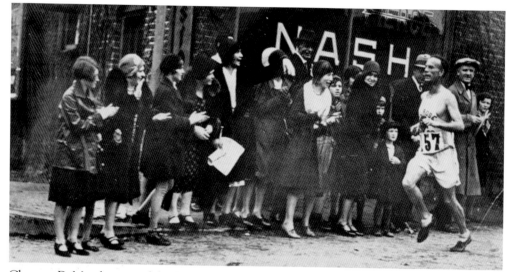

Clarence DeMar dominated the Boston Marathon during the Roaring Twenties, capturing five of his seven titles during the decade. During his amazing career, he set the course record four times and helped attract stellar fields of international challengers to Boston. DeMar was considered to be the Babe Ruth of running and joined a pantheon of 1920s sports heroes that included Ruth, tennis star Bill Tilden, football icon Red Grange, and boxer Jack Dempsey. (Courtesy of the Boston Herald.)

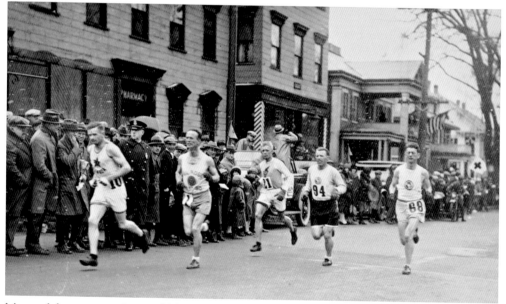

Many of the runners who would later dominate the 1925 marathon compete in a tune-up race. They are, from left to right, Victor MacAuley (10), DeMar (1), Albert Michelson (11), Schous Christianson (94), and Chuck Mellor (68). Several weeks later, on a cold day, DeMar saw his consecutive victory streak snapped at three, as Mellor beat him by 37 seconds in a time of 2:33:00. (Courtesy of the Boston Athletic Association.)

THE 1890S TO 1930

Mellor, of the Illinois Athletic Club, shown here finishing second in the 1924 Boston Marathon, came back in 1925 to best DeMar in a time of 2:33:00. Mellor chewed tobacco throughout the race and battled raw winds and snow flurries by stuffing a newspaper under his singlet. (Courtesy of the Boston Herald.)

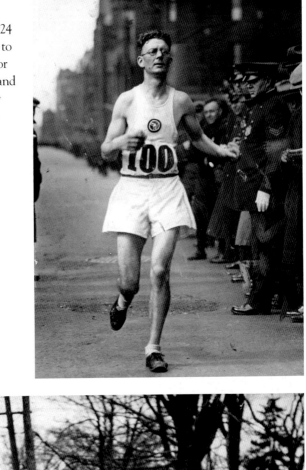

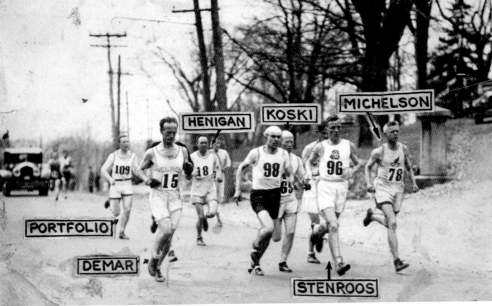

The 1926 race featured one of the great upsets in marathon history as young Johnny Miles beat a field of 126 runners that included 1924 Olympic champion Albin Stenroos and perennial favorite DeMar. (Boston Post photograph, Boston Athletic Association Collection.)

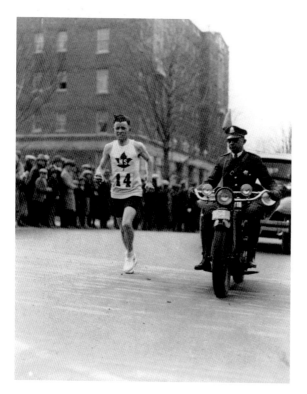

Twenty-year-old Johnny Miles, clad in sneakers he bought for 99¢ in his hometown of Sydney Mines, Nova Scotia, heads to victory in the 1926 race. (Courtesy of the Jerry Nason Collection, the Sports Museum.)

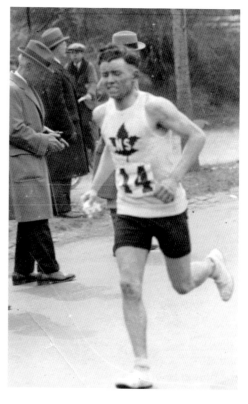

Not only did Miles possess the perfect name for a marathoner, but he also shattered Clarence DeMar's course record in 1926 with a time of 2:25:40 for the new course, which was extended from 24.5 miles to 26 miles and 209 yards for the 1923 race. (Courtesy of the Jerry Nason Collection, the Sports Museum.)

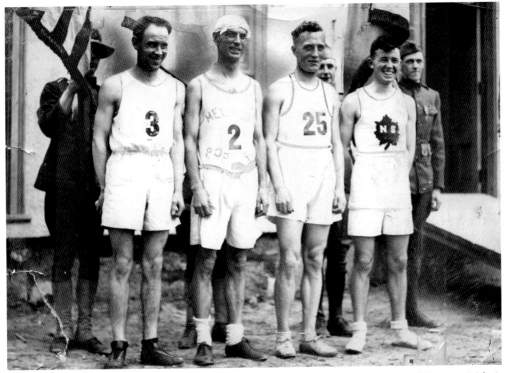

From left to right, Jimmy Hennigan, DeMar, Albin Stenroos, and Miles pose following Miles's upset victory at the 1926 Boston Marathon. Note that the runners' shoes were nothing more than either glorified street shoes or cheap sneakers. (Courtesy of the Boston Herald.)

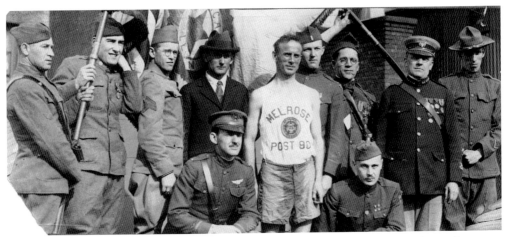

DeMar stands in his running attire with his American Legion post. Although DeMar was a relative celebrity, he still came from an era of strictly amateur runners, and his tough childhood and strong work ethic connected him to the average residents of Massachusetts. (Courtesy of the Boston Herald.)

Chicago cabbie Joie Ray was the greatest American middle-distance runner of his generation, having won the national mile championship eight times and recording a personal best of a then-amazing 4:12. He entered the 1928 Boston Marathon seeking a spot on the 1928 Olympic marathon team. In a courageous performance, he endured broken blisters that filled his shoes with blood while finishing third with a time of 2:41:56. (Courtesy of the Boston Herald.)

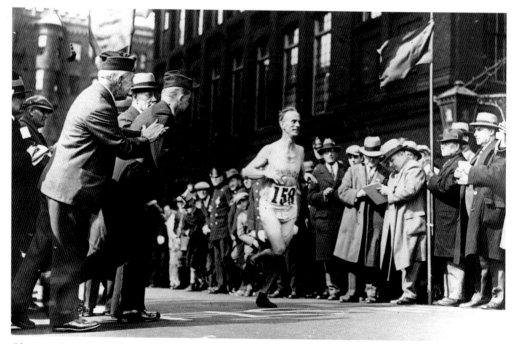

Clarence DeMar finishes up the 1928 Boston Marathon with a win and a course record of 2:37:07. The win was DeMar's sixth at Boston. He went on to win one more Boston Marathon and remains the leader in Boston Marathon men's open division wins. (Courtesy of the Boston Herald.)

THE 1890S TO 1930

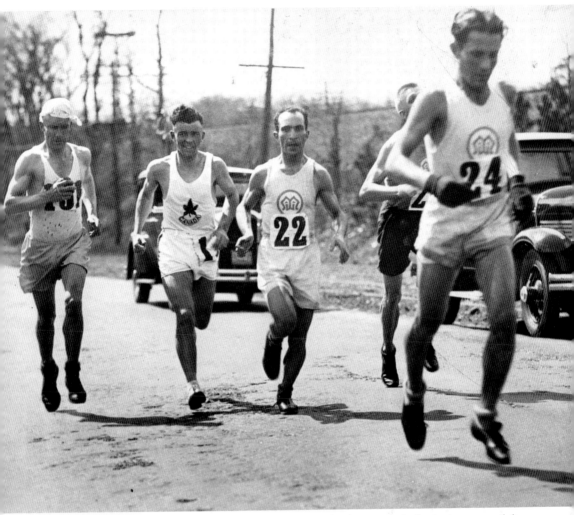

Winner Johnny Miles, second from left, hangs with a pack of runners in the early stages of the 1929 race. Miles once again set a course record in his second Boston victory, with a time of 2:33:08. The course was lengthened again in 1927 to the proper marathon distance of 26 miles, 385 yards. (Courtesy of the Boston Public Library.)

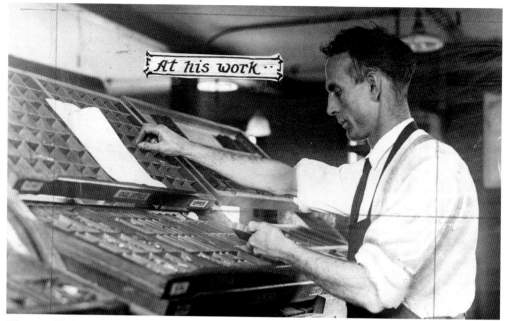

At his work..

Clarence DeMar worked as a linotyper during the day. At first a college dropout, DeMar later went back to night school and got degrees from both Harvard and Boston Universities. He often ran to and from work in order to train for the marathon. (Courtesy of the Boston Herald.)

DeMar is honored at Braves Field in Boston in a 1924 ceremony featuring the American Legion. The reticent DeMar, who once worked as a hired man on a Vermont farm, seemingly stepped from the pages of a book of Robert Frost poems to the victory podium. (Courtesy of Running Past.)

2

FROM 1930 TO 1950

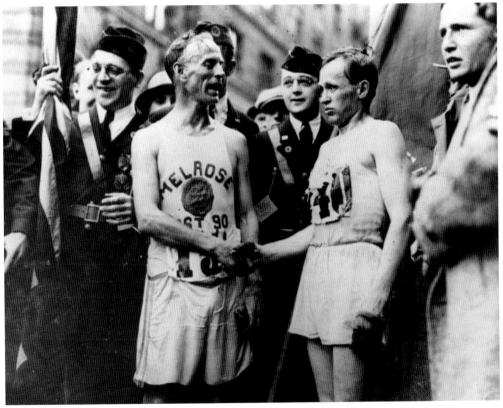

Nearly two decades after his first Boston win in 1911, DeMar (left) celebrates his seventh victory in the 1930 race, shaking hands with second-place finisher Willie Kyronen (right). It was his final win at Boston and his sixth victory out of the previous nine races. Wearing his Melrose singlet, DeMar was the first of a select group of local heroes whose number soon included Les Pawson, Ellison "Tarzan" Brown, and two extraordinary men named John Kelley. (Courtesy of the Boston Herald.)

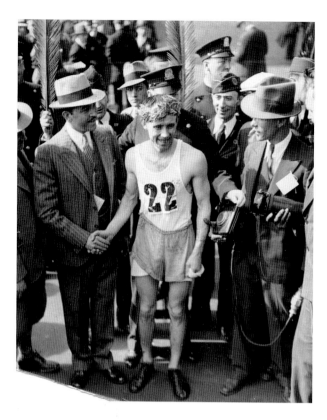

The spirit and hard work found in Jimmy Henigan were the same qualities America found over a decade later to lift itself out of the Great Depression. A workingman and father of five, Henigan still found time to put in 10 and 15 milers while training for his 13th attempt to win the Boston Marathon. The accomplished runner, known to all as "Smilin Jimmy," finally captured his Boston prize on the lucky 13th try in 1931, with a time of 2:46:45. (Courtesy of the Jerry Nason Collection, the Sports Museum.)

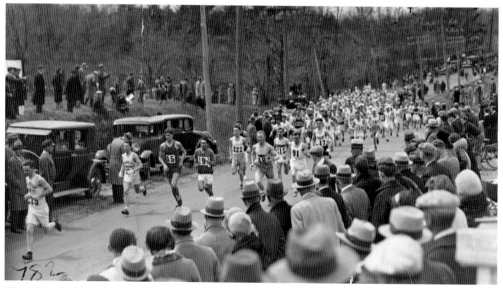

The 1932 field breaks from the starting line with eventual winner Paul deBruyn (18) striding to the outside of the pack. The former merchant seaman was particularly strong in his upper body, as he worked as a furnace stoker in a New York hotel. (Courtesy of the Boston Public Library.)

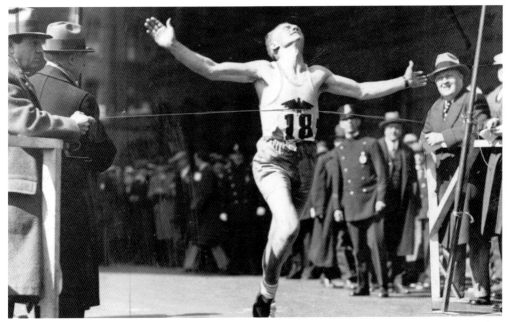

In a photograph that has become a symbol of the Boston Marathon, Paul deBruyn opens his arms like in a pose reminiscent of an ancient statue of winged victory while crossing the finish line with a winning time of 2:33:36. (Courtesy of the Boston Herald.)

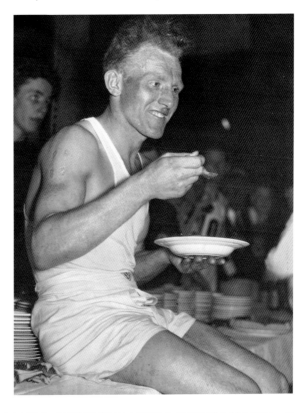

Following his victory, deBruyn enjoys a bowl of pea soup. He first asked for a bottle of beer, but prohibition was still in effect, and he downed a ginger ale before accepting the soup. (Courtesy of the Boston Public Library.)

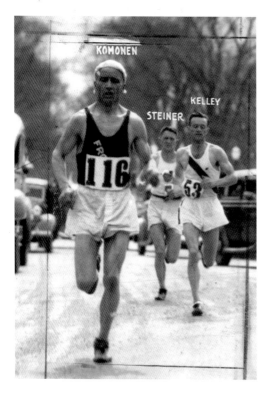

This is the eventual winner, place, and show of the 1934 contest, with Dave Komonen (left) in first, John A. Kelley (right) in second, and Bill Steiner (center) in third place, running in their finishing order through the Newton hills. Komonen's small build of about five and a half feet and 125 pounds was perfect for gliding up and down the rolling hills, and he never looked back. Emigrating from Finland to Canada, he was tiny not only because of genetics but also because his dire financial situation limited his diet. (Courtesy of the Boston Herald.)

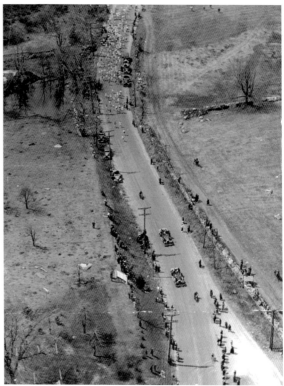

This aerial view of the 1935 pack depicts the runners heading towards Framingham. Early on in the marathon's history and especially during the Great Depression, the number of entrants remained around 200. This band of brothers were all dedicated athletes, forefathers of the more than 25,000 runners and wheelchair competitors who comprise today's marathon field. (Courtesy of the Boston Public Library.)

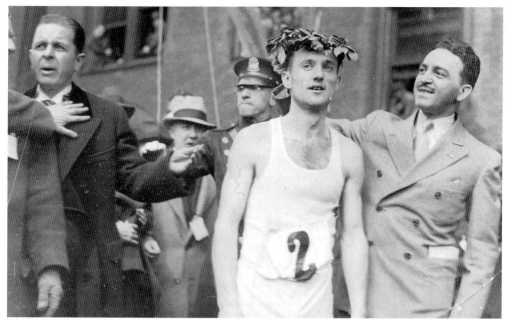

Kelley receives the 1935 Boston Marathon wreath from Boston hotelier and politician George Demeter. Demeter had the wreaths sent from Greece to Boston and also hosted many runners at his Hotel Minerva. (Courtesy of the Frederick Lewis collection.)

After his 1935 victory and numerous other impressive finishes at his home race, Kelley became a local celebrity. Newspapers printed stories about his personal life and focused on his everyman appeal. It even helped him secure a job with a florist and later with Boston Edison Company. Here he is shown in the kitchen of his house in Arlington reading of his win. (Courtesy of the Jerry Nason Collection, the Sports Museum.)

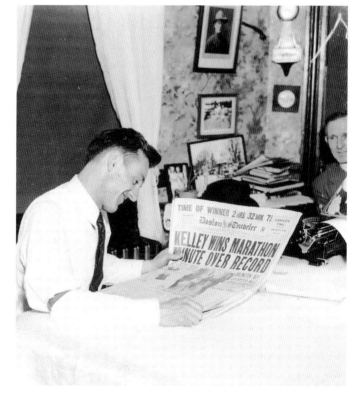

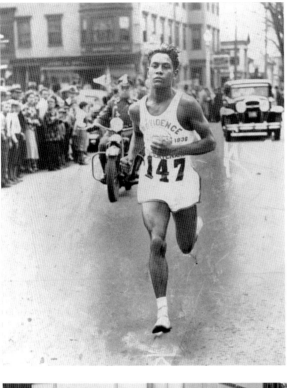

Ellison "Tarzan" Brown fought for a way out of the poverty cycle through running. Coming into the 1936 marathon with better training and proper running shoes, Brown ran to victory and continued to fight for his livelihood and the respect of his people, the Narragansett tribe. (Courtesy of the Frederick Lewis collection.)

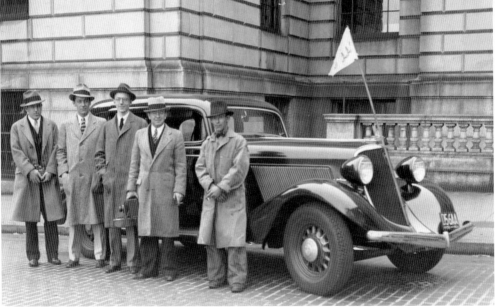

The Boston Marathon was covered by at least seven daily newspapers during the 1930s, and each equipped a special car that included reporters and photographers. The *Boston Globe* car from 1933 featured legendary reporter Jerry Nason (second from left) and executive sports editor Victor O. Jones (third from left). (Courtesy of the Jerry Nason Collection, the Sports Museum.)

FROM 1930 TO 1950

Walter Young of Verdun, Quebec, came to Boston in 1937 with the promise of a job on his local police force should he win the race. Not only did Young win the race, beating John A. Kelley by nearly six minutes, but he also ended up working for the Verdun police for nearly five decades. (Courtesy of the Boston Public Library.)

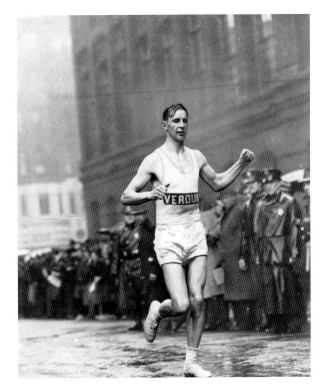

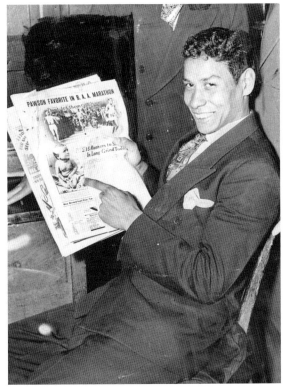

Despite the newspaper's claim, Brown, champion two years beforehand, looks ever confident before the 1938 contest. The paper's prediction proved correct, as Brown's smile was wiped away by one of the worst performances of his life, finishing over an hour behind the leaders at 3:38:59. Heavily criticized and stereotyped because of his Native American heritage, Brown found redemption a year later. (Courtesy of the Boston Herald.)

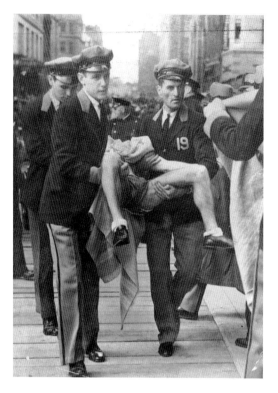

Toronto native Duncan McCallum finished in fifth place in the 1937 race and promptly collapsed at the finish line. He is shown being carried by Boston Garden ushers, who also served as finish line stewards for many years. (Courtesy of the Boston Public Library.)

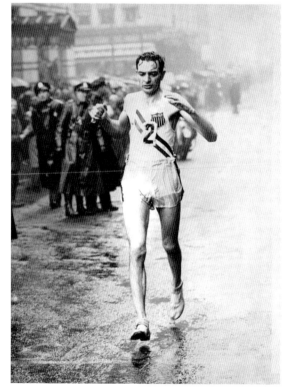

Pat Dengis's race number in 1939 was an unfortunate symbol of his success at Boston. A marathon champion of many other races, Dengis performed well at Boston but never won. Here he battles to a fourth-place finish behind an impressive lead pack. (Courtesy of the Frederick Lewis collection.)

Three-time Boston Marathon winner Les Pawson (left) toiled as a mill worker in Rhode Island, and along with fellow New Englanders John A. Kelley and Ellison "Tarzan" Brown, he defined an era that historian Frederick Lewis called the Boston Marathon's "golden era." Pawson, shown here setting a course record of 2:31:01 in 1933, was a runner of extraordinary strength who battled strong headwinds to set a record that stood for five years. (Courtesy of the Frederick Lewis collection.)

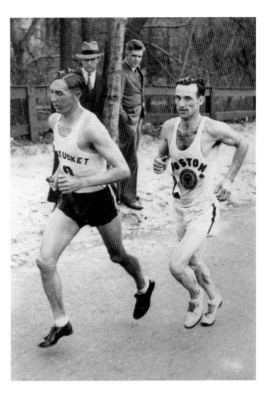

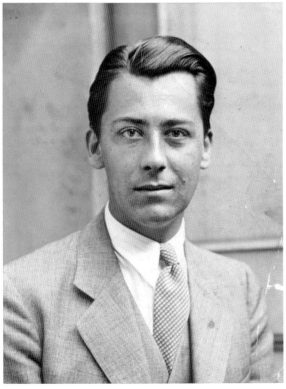

Jerry Nason of the *Boston Globe* is regarded as the James Boswell of the Boston Marathon, having covered the race from the late 1920s to his death in 1986. He once received a letter addressed simply, "Greatest Marathon Writer, Boston, Mass." His booklet on the race, published in 1970, was the first-ever history of the race. (Courtesy of the Jerry Nason Collection, the Sports Museum.)

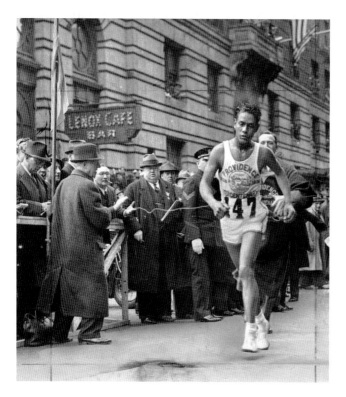

Ellison "Tarzan" Brown, shown here winning the 1936 race, was an athlete who beat incredible odds to become an international-class marathoner. Not only was he a two-time winner of the Boston Marathon, but he also shattered the course record by over two minutes in 1939 with a time of 2:28:51. (Courtesy of the Boston Herald.)

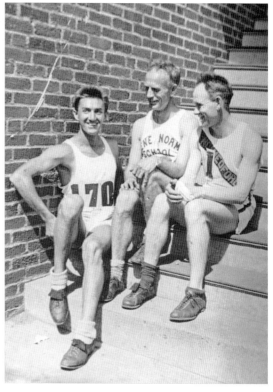

Eleven Boston Marathon victories are represented in this picture as, from left to right, Les Pawson, Clarence DeMar, and Jimmy Henigan gather to share running stories in this undated photograph. (Courtesy of the Les Pawson collection.)

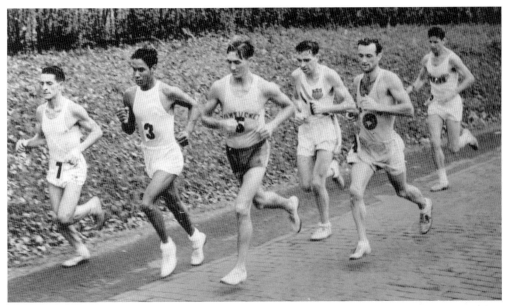

This photograph from the 1939 Boston Marathon captures the royalty of Depression-era marathoning as, from left to right, Gerard Cote, Brown, Pawson, Pat Dengis, John A. Kelley, and Don Heinicke match strides in a race that saw Brown emerge with a record-setting win. (Courtesy of the Frederick Lewis collection.)

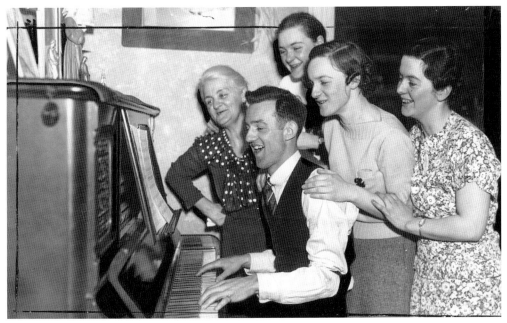

By the early 1940s, Kelley, shown here playing the piano and singing to the accompaniment of his mother and sisters, was a local hero in a city that worshipped the likes of Ted Williams, Lefty Grove, and the famed Boston Bruins Kraut Line. (Courtesy of the Jerry Nason Collection, the Sports Museum.)

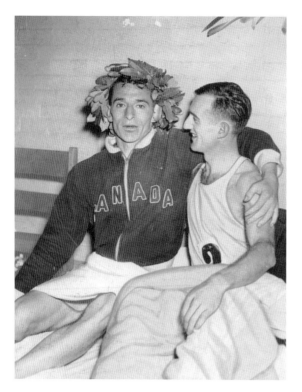

Clad in his victor's wreath and sweats, 1940 champion Gerard Cote consoles second-place finisher John A. Kelley. It marked the first of Cote's four Boston victories and the third time Kelley finished as runner-up. (Courtesy of the Frederick Lewis collection.)

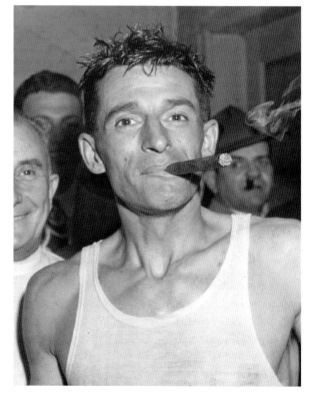

Long before Red Auerbach made victory cigars famous in Boston, Canadian runner Cote celebrated his record-setting victory (2:28:28) in the 1940 race with a stogie. The colorful Cote was also a champion snowshoe racer in Quebec. (Courtesy of the Frederick Lewis collection.)

FROM 1930 TO 1950

Boston Marathon legend John "Jock" Semple grins as he finishes the 1941 marathon in eighth place. The Glasgow native not only was a top competitor but also served as coach and father confessor to a generation of B.A.A. runners, including 1957 champion John J. Kelley. (Courtesy of the Boston Herald.)

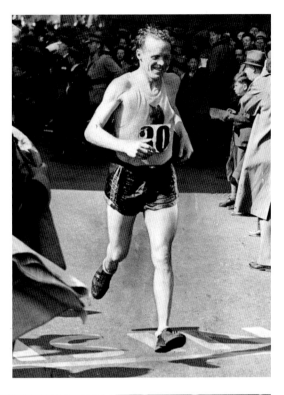

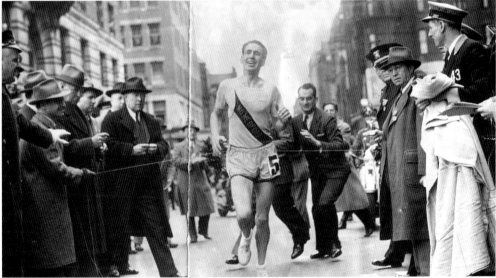

A man with a humble name and a humble profession, Joe Smith, a milkman, crossed the finish line of the 1942 race first, breaking the course record by one minute, 37 seconds with a time of 2:26:51. His winning smile marked his race strategy. He was not a runner who welcomed pain like so many marathoners and only pushed himself as long as it was still enjoyable. He was blessed with a pain-free race day and soaked up the final miles, grinning and waving his way to a historic performance. (Courtesy of the Boston Herald.)

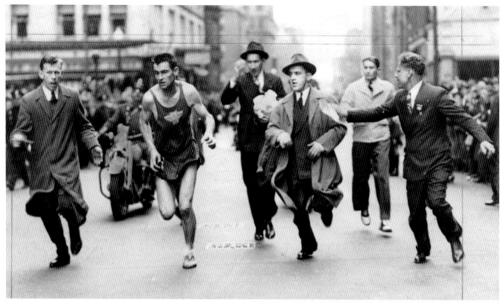

Prerace favorite Fred McGlone staggers towards the finish of the 1942 race. Because he was assisted along the way by a policeman who helped him to his feet after he had fallen for the third time on Exeter Street, McGlone was disqualified after finishing in seventh place. (Courtesy of the Boston Herald.)

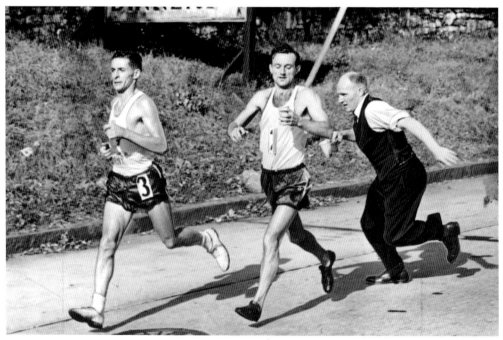

Gerard Cote (left) and John A. Kelley are handed cups of water by former Boston Marathon champion Paul deBruyn during the 1943 race. Cote bested Kelley once again by a margin of a minute and a half in the second of his four Boston wins. (Courtesy of the Boston Herald.)

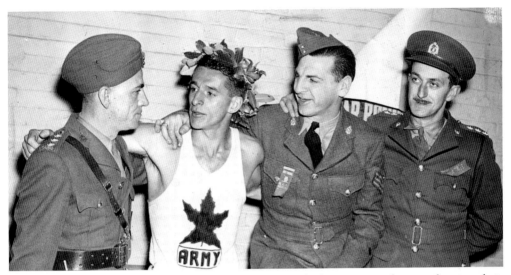

In 1943, the age of citizen soldiers had not spared even the best runners from performing their duty. At military bases across North America, the elites found time to train and came together in April to race one another. Capturing his second Boston victory, Cote let his singlet remind spectators what he was going back to. Cote, a sergeant, enjoyed his victory with fellow soldiers, including from left to right, Capt. Ernie Leurence, Sgt. William Roper, and Capt. Paul Deseve. (Courtesy of the Boston Herald.)

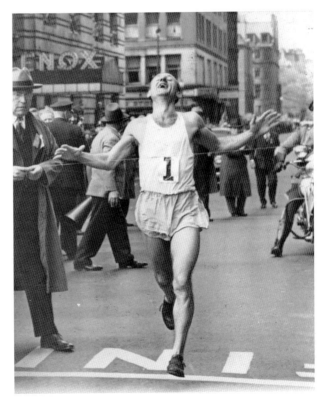

Kelley celebrates the 10th anniversary of his first Boston Marathon win with his second, as the 37 year old triumphed over the smallest field since the 1903 race. Only 67 men started the race that featured the three fastest marathon times in the world for 1945. Kelley's time of 2:30:40 was nearly a minute and a half faster than his previous winning time. (Courtesy of the Jerry Nason Collection, the Sports Museum.)

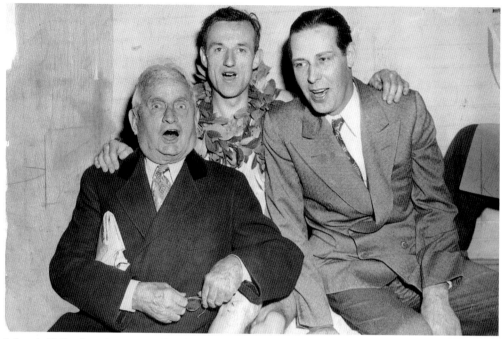

John A. Kelley loved to sing and is shown posed with politicians John "Honeyfitz" Fitzgerald (left) and Maurice Tobin following his win in 1945. (Courtesy of the Frederick Lewis collection.)

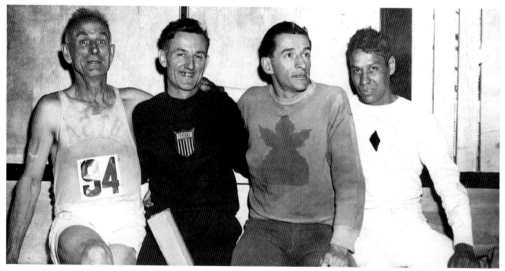

In the 50th running of the classic race, four of its past champions share a lighter moment before heading to the starting line. Pictured from left to right, Clarence DeMar, Kelley, Gerard Cote, and Ellison "Tarzan" Brown combined for 14 previous olive crowns, with Kelley set to defend the title from 1945. The foursome all had to step out of the spotlight to make room for the 1946 winner, Stylianos Kyriakides. Kelly went on to finish in his familiar second place, five minutes in front of Cote. At age 58, DeMar ran a laudable 3:09:55, finishing in 32nd place. (Courtesy of the Frederick Lewis collection.)

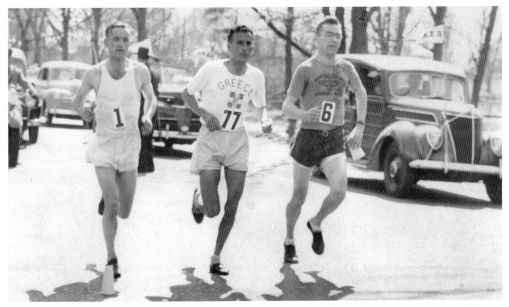

Cheered on by the women of Wellesley College, from left to right, the 1946 lead pack of Charles Robbins, Kelley, and Kyriakides pushes ahead. Kyriakides wears the traditional lucky Greek number 77. Kyriakides runs the race of his life spurred by the prospect of using his victory to garner much needed aid for his war-ravaged homeland. (Courtesy of the Kyriakides family.)

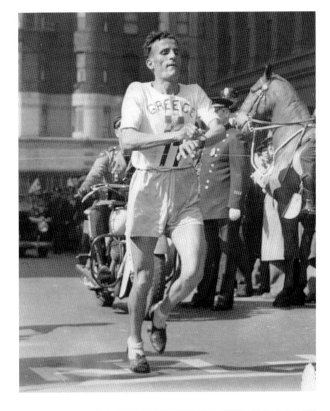

In 1946, Kyriakides's victory not only allowed him to wage a one-man Marshall Plan in aid of war-stricken Greece, but his win also garnered international press coverage for the race on its 50th anniversary. (Courtesy of the Jerry Nason Collection, the Sports Museum.)

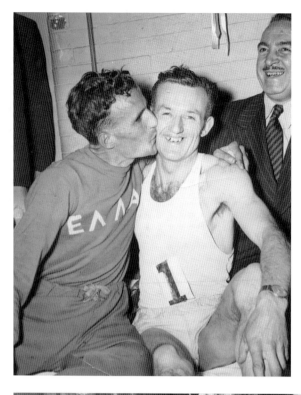

Stylianos Kyriakides kisses runner-up John A. Kelley after his dramatic win in the 1946 race. Following the race, Kyriakides spent over a month raising money for war relief in his homeland and was greeted by over a million well-wishers in a triumphant return to Athens. (Courtesy of the Frederick Lewis collection.)

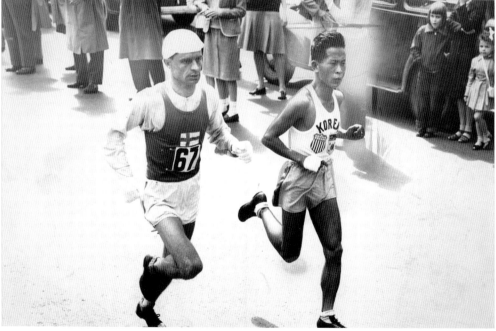

Twenty-four-year-old Korean student Yun Bok Suh (right) matches strides with Mikko Heitanen of Finland, as Suh heads to victory in the 1947 race in a record time of 2:25:39. (Courtesy of the Associated Press.)

FROM 1930 TO 1950

Local star Ted Vogel of Tufts University and the B.A.A. finished third in 1947, with a time of 2:30:10. It was the middle year in Vogel's three-year stretch of success, which saw him finish ninth, third, and second respectively. In 1948, he waged a legendary battle with Gerard Cote in which Vogel claimed the Canadian impeded his race by continually cutting across his path. The two nearly came to blows before Cote pulled away for his fourth Boston Marathon crown. (Courtesy of the Boston Herald.)

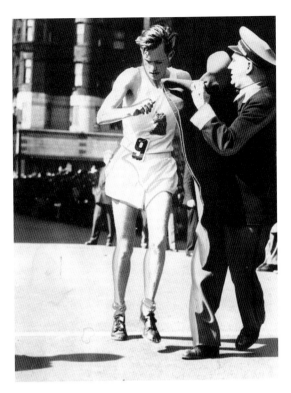

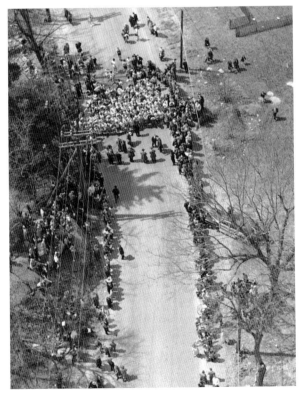

The start of the 1948 race is pictured here. By the end of the afternoon, not only did Cote capture his fourth Boston win, but he was also involved in a spat with Vogel, the runner-up. (Courtesy of the Boston Public Library.)

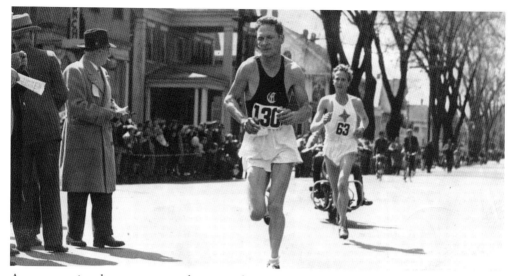

A young national cross-country champion from Sweden, Karl Leandersson (right), was good enough to be flown to Boston to compete in 1949. In a dangerously unorthodox training move, Leandersson ran a time trial for Boston one week before the race in an astounding 2:27:45. The question was no longer if he could compete but if he had spent too much energy in the trial to win in the real thing. He must have spent some of it but still had enough to win in a time of 2:31:50. (Courtesy of the Jerry Nason Collection, the Sports Museum.)

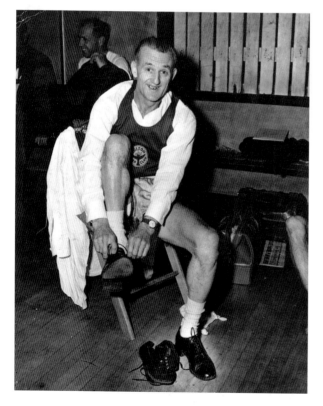

John A. Kelley was the ultimate working-class hero. Named the "Runner of the Century" by *Runner's World* in 2000, Kelley ran in all but one Boston Marathon from 1928 to 1992. Note the primitive running shoes and equipment. On most days, Kelley trained at night after toiling for the Boston Edison Company. Kelley credits his night runs for saving his life and for providing him with fresh air and exercise to balance his work-related contact with asbestos. (Courtesy of the Boston Herald.)

FROM 1930 TO 1950

3

FROM 1950 TO 1970

For the 1950 race, Korea sent three of their best marathon runners in the spirit of continuing the success that fellow Korean Yun Bok Suh found in Boston in 1947. The trio could not have had a better outcome for the race, sweeping the top three places. Here, one third of the attack, Kee Yong Ham, powers through a section of the Newton hills on his way to first place. The Korean sweep of the marathon helped restore pride to a country during hard times but irritated American runners who had to work a job along with training, because the Koreans were able to concentrate on the marathon full time. (Courtesy of the Boston Herald.)

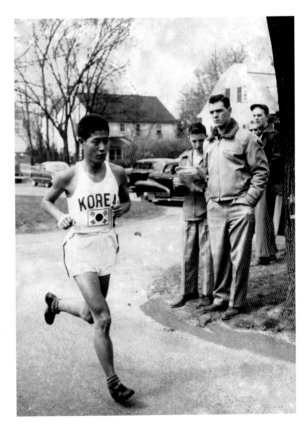

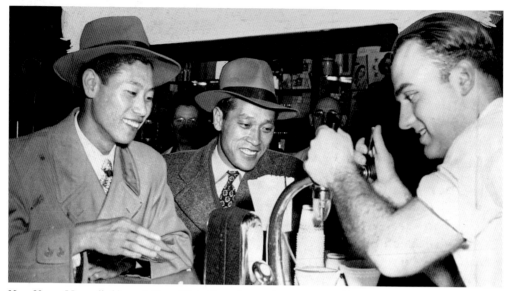

Kee Yong Ham (left) and Yun Chi Choi (center) enjoy a milk shake after their first- and third-place finishes in the 1950 marathon, respectively. The two runners were part of a Korean sweep of the top three spots at Boston that year. Choi was thought to be the fastest of the group, but he had a tough day, and after stopping just before the finish line to attend to his leg, he needed to sprint to secure third and the sweep. (Courtesy of the Boston Herald.)

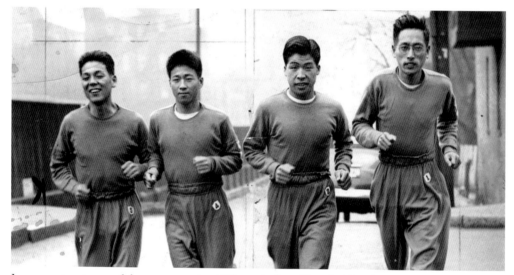

Japan sent a team of four runners in 1951, including Shigeki Tanaka, Yoshitaka Uchikawa, Hiromi Haigo, and Shunji Koanagi, pictured here from left to right on a training run through Boston. John Patrick Lafferty, who finished fourth the previous year, was now a member of the B.A.A., and he and Jesse Van Zant were the two the B.A.A. was counting on to take home the title. The Japanese team took first, fifth, eighth, and ninth places. Tanaka was the winner, coming ahead of Lafferty by a sound three minutes and 30 seconds. (Courtesy of the Boston Herald.)

Guatemalan Doroteo Flores finishes the 1952 race in first place, proving he was the only one ready for the hot temperatures that day. Since the end of World War II, an American had not won in Boston, which agitated many domestic runners. Although Flores's time of 2:31:53 was not a fast winning time, he still came in almost five minutes ahead of second-place finisher Vic Dyrgall. The 200 entrants for the race had a tough time with the weather, and only the top 10 finishers were able to break three hours. (Courtesy of the Boston Herald.)

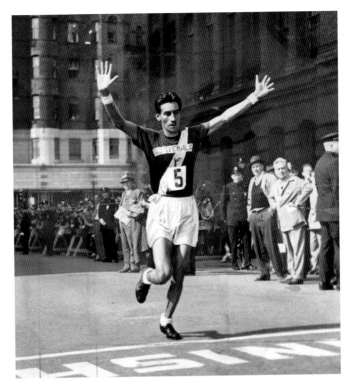

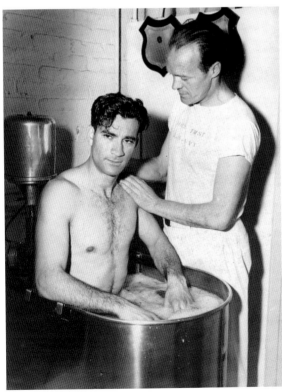

John "Jock" Semple (right) takes care of Van Zant, who hoped to take home the olive crowns as a member the B.A.A in 1950. Van Zant traveled from California to Boston, working odd jobs to have enough money to live and run. He was a true amateur athlete. Semple hoped to coach him into a champion. In 1950, Van Zant was up against a trio of Korean runners. He got an early lead, but the Koreans kept along with him until mile 17, where Van Zant dropped out, letting the Korean runners sweep the top three spots unopposed. (Courtesy of the Boston Herald.)

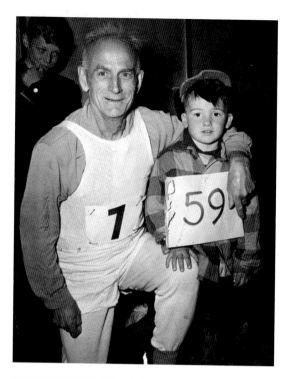

Sixty-six-year-old Clarence DeMar greets four-year-old Tommy Gasset of Hopkinton prior to the 1954 race. DeMar was the John A. Kelley of his day, a former champion who endured as a Boston Marathon competitor for years after his glory days. (Courtesy of the Boston Public Library.)

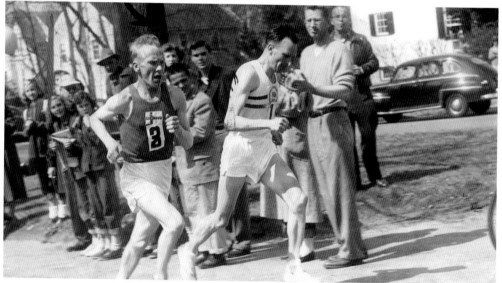

Veikko Karvonen (left) and Jim Peters (right) battle up Heartbreak Hill. Peters, an Englishman, was considered by most to be the best marathoner in the world. He had the best times, but those performances were met with some skepticism by people who thought he ran them on short courses. Peters wanted to win Boston to prove his case for best runner in the world. Karvonen, from Finland, was a close second in the previous Boston Marathon, and he was going for the win in 1954. He got that win with a time slower than his second-place performance, and Peters had to settle for second. (Courtesy of the Boston Herald.)

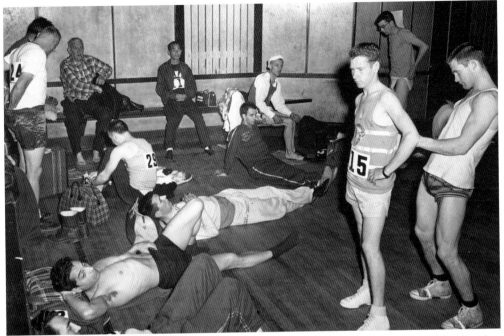

John A. Kelley prepares for the 1955 race, as George Rolland of Toronto gets his singlet number attached. (Courtesy of the Boston Public Library.)

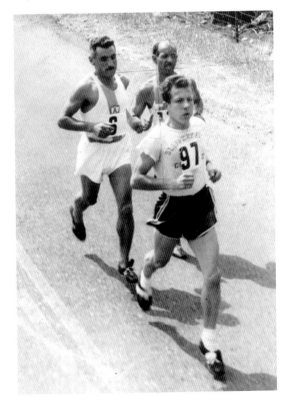

Nick Costes of Ferrell, Pennsylvania, leads the pack coming through Ashland at the start of the 1955 race. Costes, a top American contender, held on for third place behind winner Hideo Hamamura of Japan. (Courtesy of the Boston Herald.)

THE BOSTON MARATHON

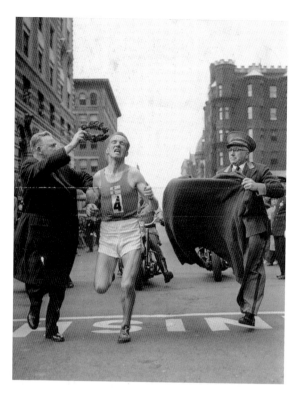

Twenty-seven-year old Finnish army sergeant Antti Viskari qualified for his place in the 1956 Boston Marathon by winning an unorthodox indoor marathon in his frozen homeland. At Boston, he bested hometown favorite John J. "the younger" Kelley by the narrow margin of 17 seconds for a time of 2:14:14. Following the race, the course was discovered to have been 176 yards short of the regulation distance of 26 miles 385 yards. (Courtesy of the Boston Public Library.)

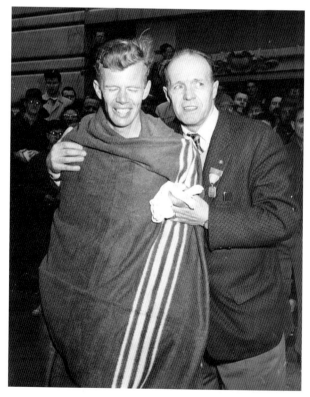

John "Jock" Semple drapes a blanket around Kelley following the 1956 race. Semple served as coach and father confessor to the Boston University student and helped him become the best American marathoner of his generation. (Courtesy of the Boston Herald.)

FROM 1950 TO 1970

Semple, the B.A.A. coach and race coordinator, escorts Kelley from the finish line of the 1957 race after he became the first B.A.A. runner to win in a course record time of 2:20:05. Kelley's victory would stand as the sole American victory in the race between that of his namesake John A. Kelley in 1945 and his protégé Amby Burfoot in 1968. (Courtesy of the Boston Herald.)

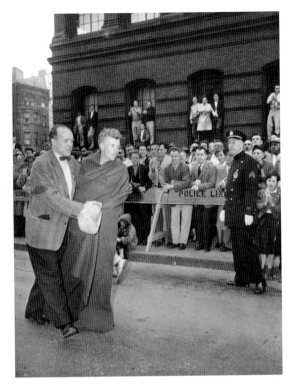

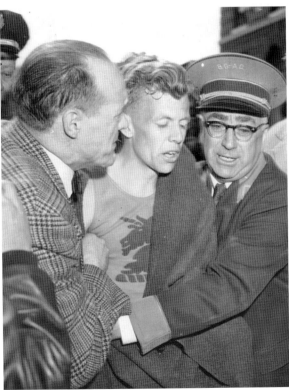

John J. Kelley nearly passes out following his record-setting win in the 1957 race. He is shown being held up by Semple (left) and an unidentified man. (Courtesy of the Boston Herald.)

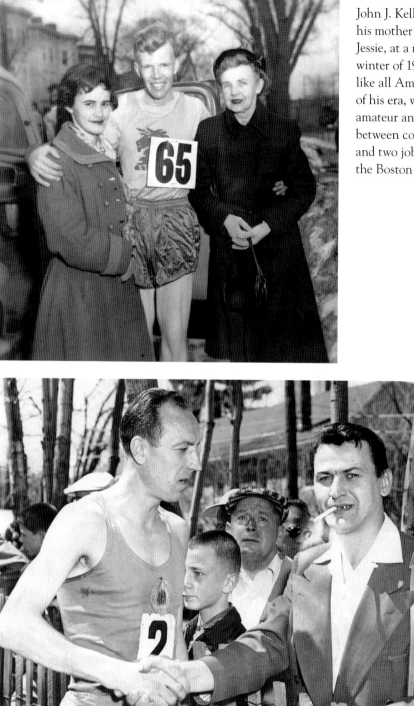

John J. Kelley poses with his mother and wife, Jessie, at a race in the winter of 1956. Kelley, like all American runners of his era, was a strict amateur and trained in between college classes and two jobs. (Courtesy of the Boston Herald.)

Franjo Mihalic (left) of Yugoslavia greets a fellow countryman prior to the start of the 1958 race. Mihalic, a former world cross-country champion, won the race by nearly five minutes over defending champion Kelley on an unseasonably warm day. (Courtesy of the Boston Herald.)

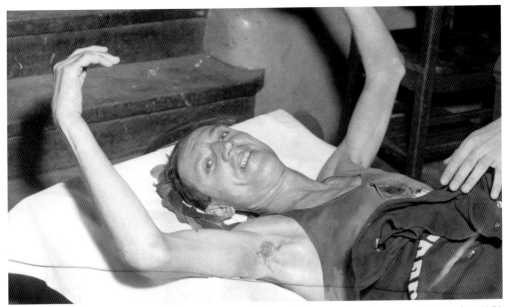

Mihalic makes a wan gesture of victory from a cot following his decisive win in the 1958 race. His winning time of 2:25:54 was five minutes short of the course record but was impressive considering the blistering conditions in which the race was held. (Courtesy of the Boston Herald.)

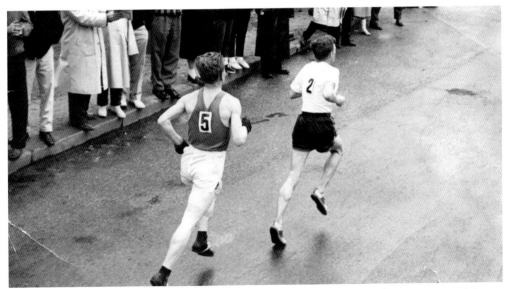

Eino Oksanen (5) goes after Kelley up the first of the Newton hills on a cold, rainy April day in 1959. Oksanen followed right behind Kelley for 24 miles until he made a move on the bridge just before Kenmore Square on his way to victory over the 1957 marathon winner. Oksanen went on to win the race again in 1961 and 1962. Kelley continued to race at Boston, but his win in 1957 remained the only one for him and the only one for the B.A.A. (Courtesy of the Jerry Nason Collection, the Sports Museum.)

John J. Kelley and Eino Oksanen (right) battle up Heartbreak Hill in the 1959 marathon. Oksanen stuck behind Kelley for almost the entire race, finally pulling ahead of him with two miles left to take his first of three Boston victories. The two found each other in a close race once more in 1961, with Oksanen taking the olive crown again by only 25 seconds. (Courtesy of the Jerry Nason Collection, the Sports Museum.)

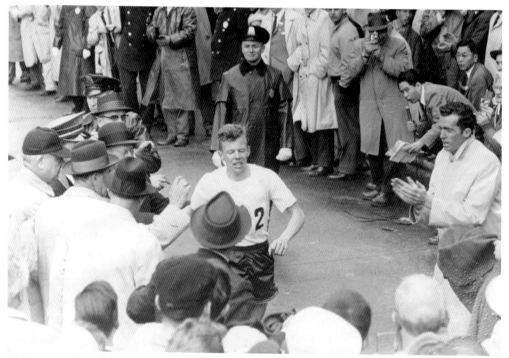

Kelley runs through a corridor of cheering fans while finishing second to Oksanen in their epic duel in 1959. (Courtesy of the Boston Herald.)

The countrymen Veikko Karvonen (left) and Oksanen are together as Oksanen answers questions after his marathon victory in 1959. Karvonen had won the race five years beforehand and finished fourth in 1959. Kelley finished second for a consecutive year after winning the race with a course record in 1957. Oksanen went on to win again in 1961 and 1962, three quarters of a Finnish four-year sweep, which also included Paavo Kotila one year after Oksanen's first Boston win. (Courtesy of the Boston Herald.)

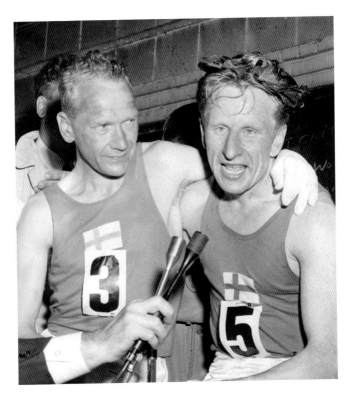

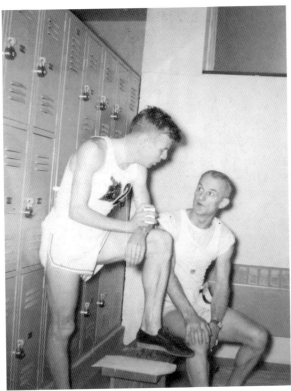

The two John Kelleys confer prior to one of their many Boston Marathons. Not only were both champions, but they also defined the role of heartbreak kids, as the elder Kelley finished as runner-up a record seven times, and the younger Kelley finished second on five occasions. (Photograph by Jessie Kelley.)

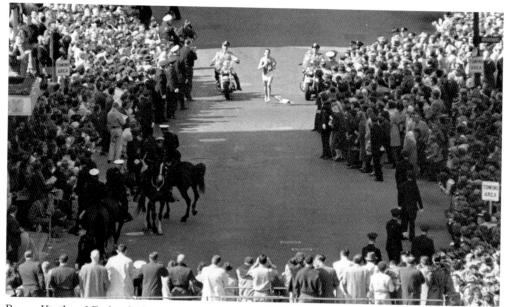

Paavo Kotila of Finland closes out the final yards of his marathon win in 1960. Police were needed on the edges of the course to hold back the mass of fans at the finish line. Photographers stand elevated in the bleachers, capturing the premier marathon in the United States. (Courtesy of the Boston Herald.)

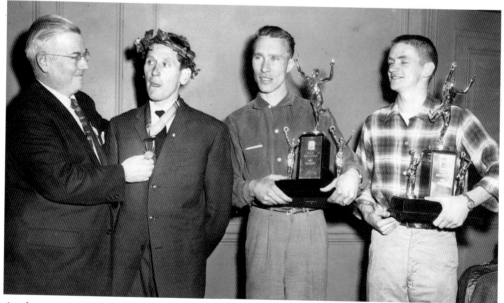

As chairman of the marathon committee, Will Cloney awards the top three finishers of the 1960 race with their prizes. The winner, Kotila (second from left) continued the excellent performances of Finnish runners throughout the 1950s and early 1960s. On the right are Americans James F. Green (right), third place; and Gordon McKenzie (second from right), second place; holding up their trophies. (Courtesy of the Jerry Nason Collection, the Sports Museum.)

FROM 1950 TO 1970

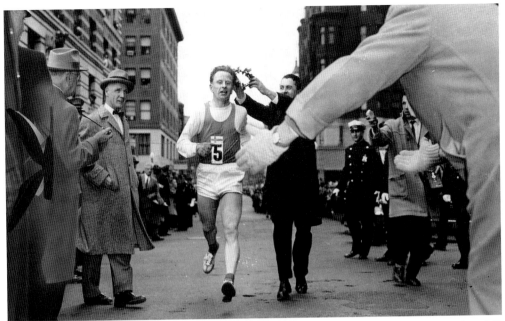

An official tries to crown champ Eino Oksanen a couple strides before the finish of the 1961 race. Oksanen won the race in 2:23:29, 47 seconds slower than his win two years earlier in 1959. (Courtesy of the Boston Herald.)

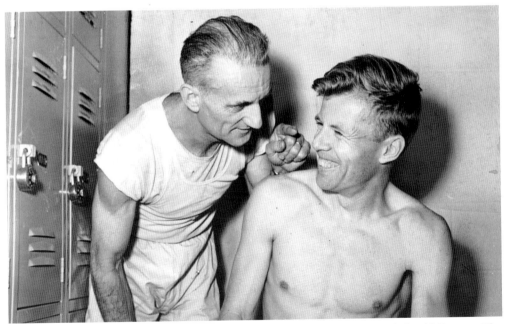

John A. Kelley (left) and John J. Kelley joke around before the start of the 1962 race. The younger Kelley, who finished in a familiar fourth place, could stand to listen to his elder, who at age 54 finished in 25th place during the race and was also used to coming up just short at Boston, placing second seven times. (Courtesy of the Jerry Nason Collection, the Sports Museum.)

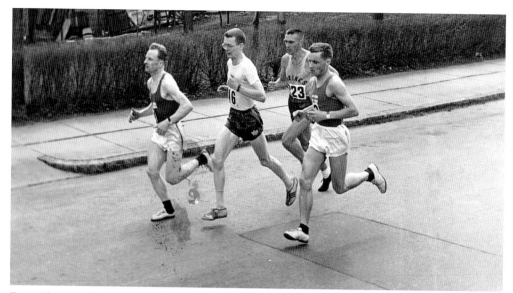

Eino Oksanen (far left) and the 1962 lead pack run through the suburbs on their way to Boston. Oksanen eventually pulled ahead to his third Boston victory in four years. The other men in the pack, from left to right, Orville Atkins, Alex Breckenridge, and Paavo Pystynen all went on to finish in the top five, while John J. Kelley (not pictured) came up from behind to take fourth place. (Courtesy of the Boston Herald.)

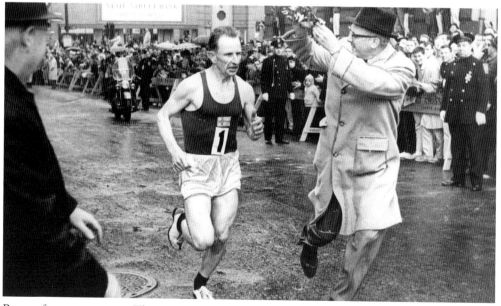

Boston fire commissioner Thomas J. Griffin runs alongside Oksanen, trying to give him the olive crown he just earned in the 1962 race. It was Oksanen's second win in a row, his third victory in four years at Boston. It was his slowest winning time, but he was the man to beat on the roads, and Kelley, feeling too much pressure to win Boston every year, came across the finish almost five minutes after Oksanen to place fourth. (Courtesy of the Boston Herald.)

FROM 1950 TO 1970

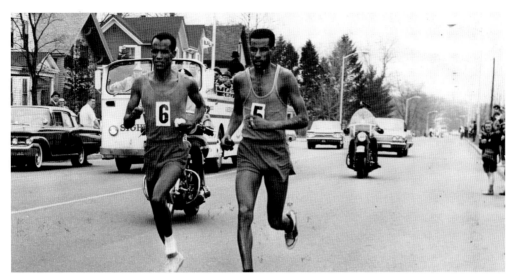

Ethiopians Mamo Wolde (left) and Abebe Bikila run together in the lead through Wellesley. In 1960, Bikila had become the first man from Africa to win the Olympic marathon, doing so barefoot, and in 1963, he attempted to break the jinx of Olympic winners at Boston. Although they faded in that race, Bikila to fifth place and Wolde to 12th, both went on to be the next two Olympic champions in the marathon. Bikila won in 1964 with a world record 2:12:11, and four years later Wolde took gold. (Courtesy of the Boston Herald.)

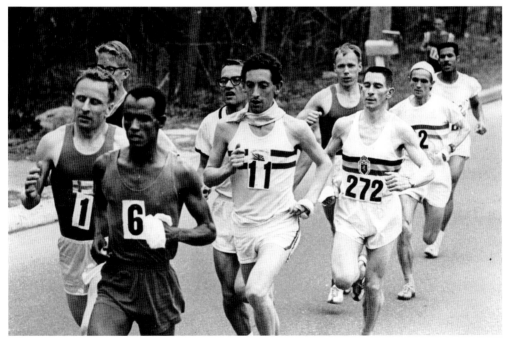

Wolde (6) of Ethiopia leads the pack early on in the 1963 race. He and his countryman Bikila led for over half the race, but Belgian Aurele Vandendriessche (272) came on late in the race to get first and a course record. Wolde faded to 12th. (Courtesy of the Boston Herald.)

A cameraman captures Belgian Aurele Vandendriessche finishing up his second straight marathon win in 1964. The Belgian ran a more conservative race than in 1963 and was off his course record time by one minute and one second. He ran a smart race, staying with the pack until the late miles when he was sure no one would follow him as he made his inevitable surge towards the finish. (Courtesy of the Boston Herald.)

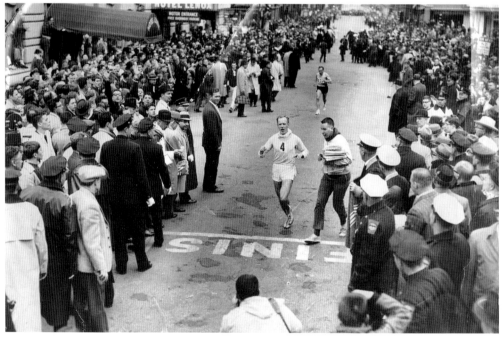

Tenho Salakka of Finland comes in second place in 1964. Vandendriessche took first place, and perennial contender John J. Kelley dropped to a seventh place finish. (Courtesy of the Jerry Nason Collection, the Sports Museum.)

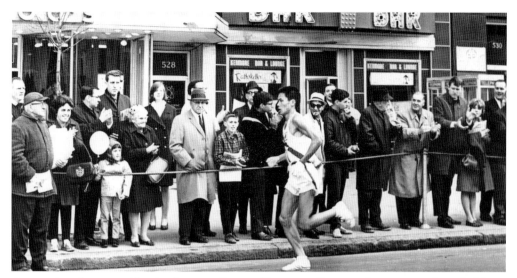

A crowd gathers outside the Lounge Bar in Kenmore Square, cheering on Japan's Morio Shigematsu as he makes his way to first place and a course record. In 1965, the Japanese team dominated the course, and the first American and Massachusetts resident, Ralph Buschmann, crossed in seventh place. But the marathon was still owned by the people of Boston, who came out to support the athletes—world-class runners, local heroes, friends, and neighbors. (Courtesy of the Boston Herald.)

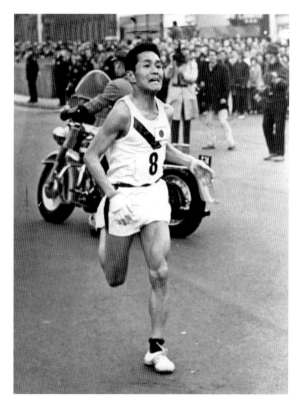

Takayuki Nakeo pushes forward on his way to third place in the 1965 marathon. Nakeo was the third runner in the Japanese sweep of the first three spots, the first country to take the top spots since Korea sent its dominant team in 1950. Japan also took fifth and sixth place in the race. (Courtesy of the Boston Herald.)

THE BOSTON MARATHON

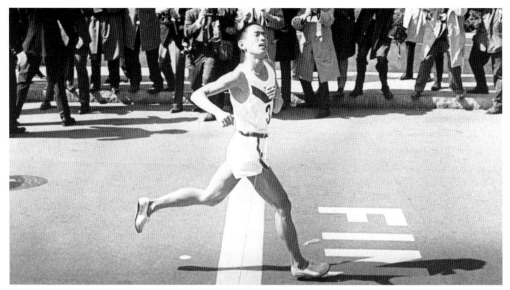

Kenji Kimihara breaks the tape and leads a consecutive year of Japanese dominance in 1966. Within the next 60 seconds, three more of his countrymen came in, sweeping the top four spots in the marathon. The year before, Japan took the first three places along with fifth and sixth places, led by winner Morio Shigematsu, who dropped the course record to 2:16:33. (Courtesy of the Boston Herald.)

Roberta Gibb runs through the rain and through the male runners in 1967. The previous year, she became the first woman to complete the Boston Marathon, but because she was a woman, she had to run unofficially. Again, Gibb ran unofficially, the pioneer for woman at Boston, who won the women's division unofficially the first three years of women racing. (Courtesy of the Boston Herald.)

David McKenzie begins to push ahead of the pack on the first of the Newton hills in 1967. The New Zealander focused much of his training on hills, and he was prepared to surge through the rolling hills and drop the competition. McKenzie kept his lead through the finish, breaking the course record with a time of 2:15:45. (Courtesy of the Boston Herald.)

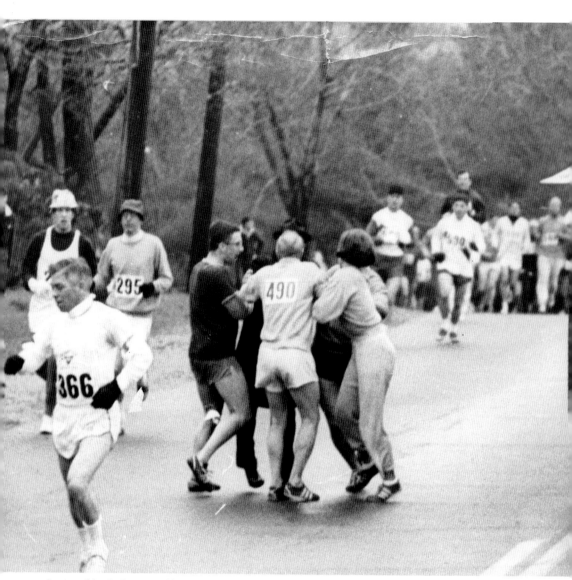

Inspired by Roberta Gibb, who in 1966 was the first woman to complete the Boston Marathon, albeit unofficially, Katherine Switzer decided to run it too. Switzer challenged the mold of an all-male sports world throughout her college years, competing on men's teams, and was coached by Arnie Briggs at Syracuse University to run a marathon. Switzer wanted to run officially, though, and sent all the required forms to the B.A.A. under the name K. Switzer. A few miles into the race, B.A.A. officials noticed a woman running with No. 261 and took action. A pile-up ensued around her. John "Jock" Semple and Will Cloney tried to rip off Switzer's number and throw her out of the race. She was defended by her coach and her hammer-throwing boyfriend, who knocked Semple to the ground. Switzer went on to finish the race with no official time, only an estimate of 4:20, an hour slower than Gibb's finishing time. Switzer was the biggest story of the 1967 race, but the B.A.A. stuck with its no-women stance for a few more years. (Courtesy of the Jerry Nason Collection, the Sports Museum.)

FROM 1950 TO 1970

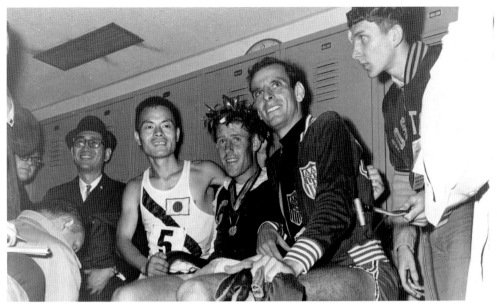

Pictured from left to right, the three heroes of the 1967 race, Yutaki Aoki of Japan (5), David McKenzie of New Zealand, and Tom Laris of New York, answer questions and pose for pictures. McKenzie won the race, Laris was second, and Aoki was third. (Courtesy of the Boston Herald.)

Amby Burfoot was made to be a distance runner. His tall, lanky build combined with natural athleticism gave him all the physical tools, and his confident, introverted mind-set guided him through training. In high school, he was coached by John J. Kelley, and in college, he trained with Olympian Jeff Galloway and roomed with youngster Bill Rodgers. But Burfoot was not handed the 1968 Boston Marathon win. He trained at an almost absurd intensity, logging 39 miles on one day alone. He put it all together on race day, pulling ahead of the pack on the hills and holding on for victory. (Courtesy of the Boston Herald.)

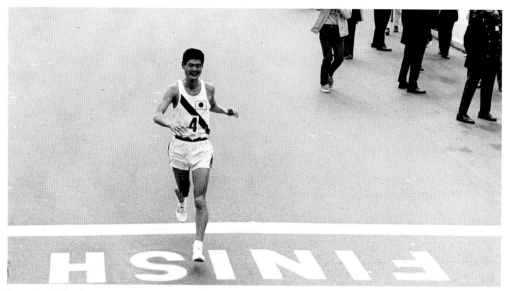

Japan's Yoshiaki Unetani destroys the 1969 field as well as the course record. His first-place time of 2:13:49 was nearly four minutes faster than the second-place finisher and amazingly did not beat his personal best, 2:12:40, which he set in Fukuoka. Unetani led the huge 1969 marathon, which featured 1,152 official starters, the largest number of entrants for a marathon ever. (Courtesy of the Boston Herald.)

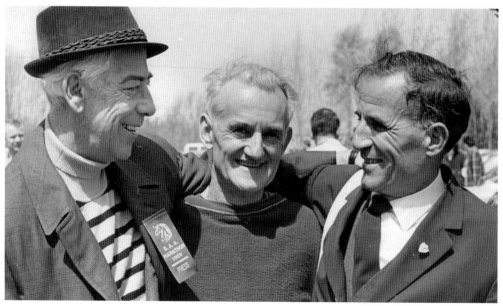

John A. Kelley (center) stands with his old marathon pals, Stylianos Kyriakides (right) and veteran marathon reporter Jerry Nason at the 1969 race. Kelley was coming off one of the rare years in which he did not race Boston and made sure he was not forgotten, running an impressive 3:05:02 at age 61. He was the number one runner aged 60 or older. (Courtesy of the Jerry Nason Collection, the Sports Museum.)

4

FROM 1970 TO 1990

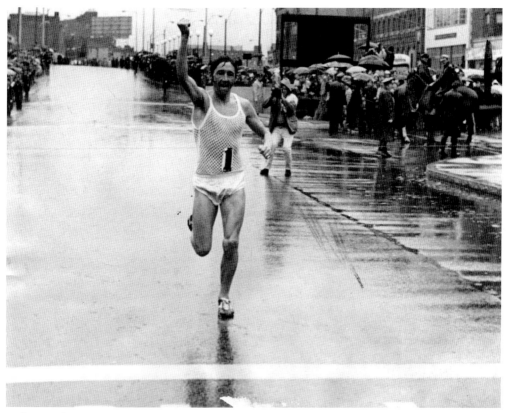

A few strides away from victory, Englishman Ron Hill raises a fist in victory at the end of the 1970 race. Hill, a textile chemist from Lancashire, England, and the owner of a great runner's name, simply ran one of the great marathons of all time. On a cold, rainy day, Hill must have felt like he was back home training in the Penines while setting a new course record of 2:10:30. (Courtesy of the Jerry Nason Collection, the Sports Museum.)

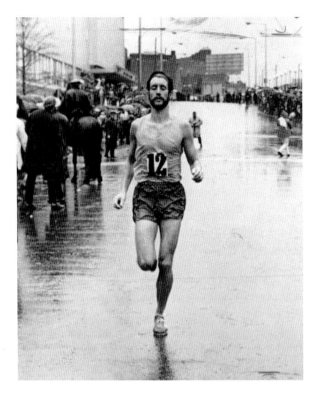

Alone in the rain and the cold, Eamon O'Reilly secures second place in the 1970 contest. O'Reilly surprised everyone but himself with his performance, dropping over five minutes from his previous personal best. His late charge, hampered by a leg cramp in the final five miles, pushed Ron Hill to a new course record of 2:10:30. The big performances on that April day were a sign of things to come in the running boom of the 1970s. (Courtesy of the Jerry Nason Collection, the Sports Museum.)

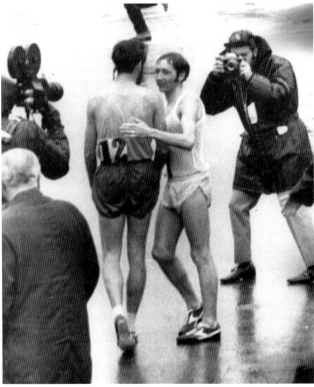

Hill (right) waits in the cold and rain to congratulate second-place finisher O'Reilly. Hill, of England, dropped the course record on the wet, miserable day. (Courtesy of the Boston Herald.)

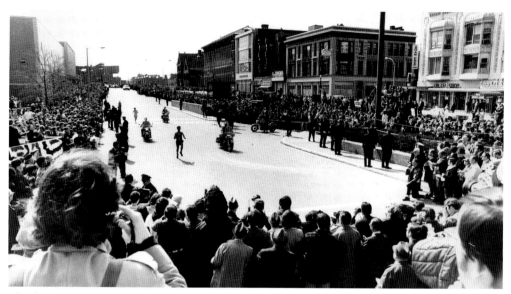

The large crowd awaits the top finishers in the 1971 marathon. Alvaro Mejia was able to edge Pat McMahon by five seconds for the win. The two ran together through the brutal heat, a cruel opposite from the year before. That race was McMahon's last due to injuries, though he continued to be an active member of the B.A.A., coaching and helping out on race day. (Courtesy of the Boston Herald.)

McMahon (center) leads the pack of the 1971 race, pursued by eventual winner Mejia (in the dark singlet and moustache) and other competitors. Upon arrival at the Newton hills, the pack dwindled to just McMahon and Mejia. The two ran stride for stride on a hot day. McMahon tried to pull ahead in the final stretches, but overflowing crowds ruined his tangent on the Hereford Street turn, and he was forced to sprint against Mejia, who won by five seconds, the smallest margin of victory in the men's race at that time. (Courtesy of the Boston Herald.)

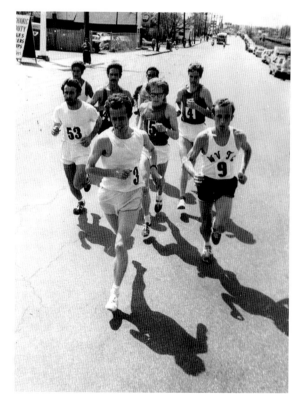

THE BOSTON MARATHON

In 1971, Cambridge native Sara Mae Berman won her third Boston Marathon in a row. She was not allowed to wear a racing number in any of them, and all of her wins have the asterisk of being listed as unofficial. The following year, women were finally official entrants in the race, but Berman had left the best of her performances in the years past, finishing 40 minutes behind her 1971 time, with a 3:48:30 race. (Courtesy of the Boston Herald.)

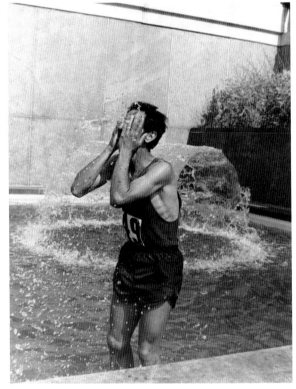

Alvaro Mejia cools off in the Prudential Center fountain after winning the brutally hot 1971 race in stunning fashion, a finish only upstaged by the 1982 race. The underdog Mejia waited until the final 400 yards to pass the favorite, Pat McMahon, and was able to out kick him by five seconds. (Courtesy of the Jerry Nason Collection, the Sports Museum.)

Eugene Roberts proves that the most courage is found at the back of the pack. Roberts, a high school track star in Maryland, lost his legs in a land mine explosion while serving in Vietnam but kept alive his dream of finishing the Boston Marathon. He devised a system of "walking," by pulling himself with his arms while under canvas skids. Only later did the wheelchair events become a regular part of Boston, in large part because of Roberts. (Courtesy of the Boston Herald.)

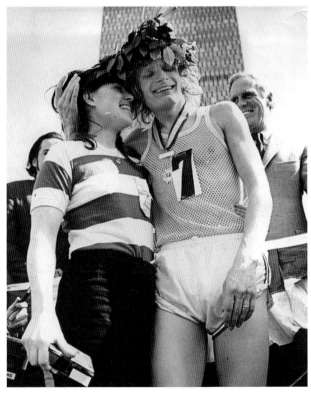

Olavi Suomalainen of Finland celebrates his 1972 victory with his wife after running a remarkable marathon debut. Suomalainen ran his race carefully and meticulously, just the way he had been training on the snowy trails of his homeland. He waited until the Newton hills to make his move on the leaders. With a strong finish, he held off a late surge by Victor Mora and came in at 2:15:39. (Courtesy of the Jerry Nason Collection, the Sports Museum.)

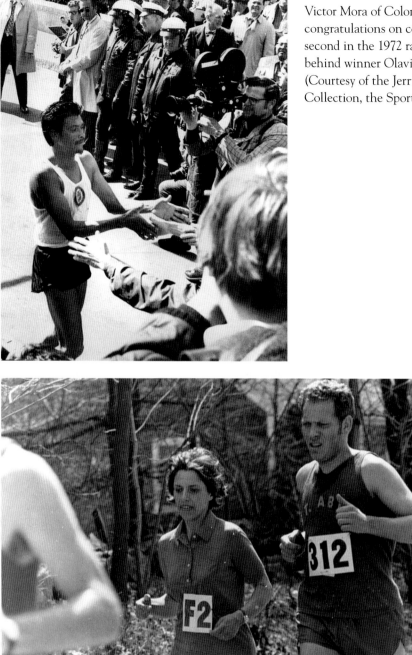

Victor Mora of Colombia receives congratulations on coming in second in the 1972 race, 18 seconds behind winner Olavi Suomalainen. (Courtesy of the Jerry Nason Collection, the Sports Museum.)

Nina Kuscsik runs alongside the men in the 1972 event, the first Boston Marathon to officially admit women. Kuscsik earned the distinction of being the first official woman's victor with a time of 3:10:26. Kuscsik also had the distinction of being the first female competitor in the New York City marathon and was a two-time winner of that event. (Courtesy of the Jerry Nason Collection, the Sports Museum.)

FROM 1970 TO 1990

Students follow German Lutz Phillip on their bikes through Wellesley in 1973. Phillip went on to finish in 11th place. Many Boston Marathon veterans regard the miles through Wellesley as their favorite because of the enthusiasm and support of the college students there. (Courtesy of the Jerry Nason Collection, the Sports Museum.)

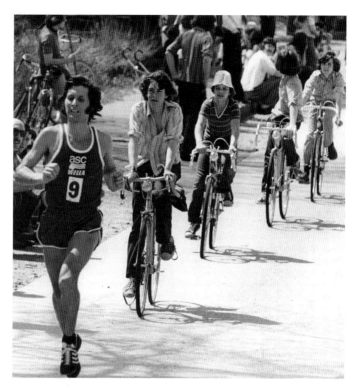

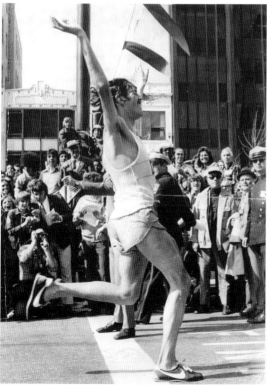

Eugene, Oregon, native and 1972 Olympian Jon Anderson battled warm conditions to upset defending champion Suomalainen and the hardworking Tom Fleming and win the 1973 race in a time of 2:16:03. Anderson soaks up the win at the finish line, wearing a pair of the newly launched Nike "Boston" racing flats. (Courtesy of the Jerry Nason Collection, the Sports Museum.)

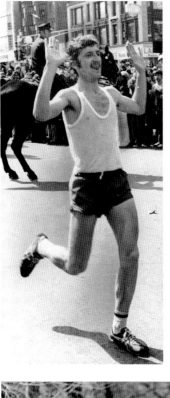

Tom Fleming trained as hard as anyone in the world and expected to win Boston in 1973 and 1974. He ended up finishing second both years, adding the prime marathon to his resume. (Courtesy of the Jerry Nason Collection, the Sports Museum.)

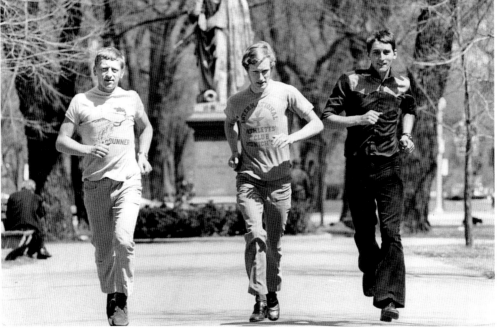

From left to right, the team of Welsh runners, including John Walsh, Bernard Plain, and Tony Davies, prepare for the 1973 marathon. Plain finished the best out of the three, coming in fourth overall with a time of 2:21:10. (Courtesy of the Jerry Nason Collection, the Sports Museum.)

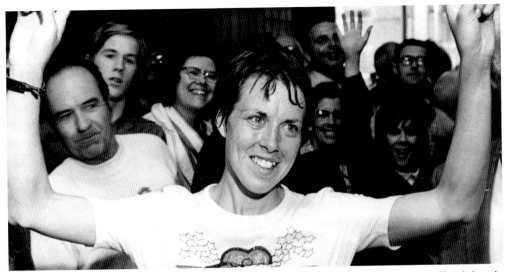

Jackie Hansen celebrates after winning the 1973 marathon, as only the second official female winner. Finishing in 3:05:59, she set a course record and defeated inaugural champ, Nina Kuscsik, but still had not met her full potential. Within two years, a tougher training regimen helped her break the world record twice, lowering it in 1975 to a then-unimaginable 2:38:19. Along with her accomplishments on the roads, Hansen also became a vocal pioneer for women's participation in long-distance Olympic events. (Courtesy of the Jerry Nason Collection, the Sports Museum.)

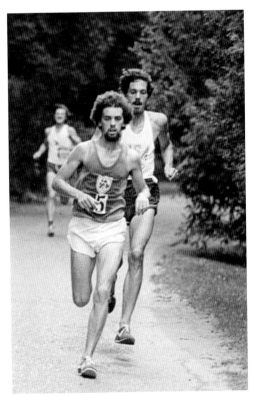

Neil Cusack, winner of the 1974 Boston Marathon, is shown here representing Ireland in the 1972 Olympics. Cusack did not get a medal in 1972 but made up for it by winning Boston, solidly beating Fleming, who came in second for two years in a row. (Photograph by Rick Levy.)

Michiko Gorman is crowned champion of the 1974 race. At age 38, Gorman had surprisingly only been running for five years, and despite her late start and lack of experience, she held what was thought to be the women's world marathon record of 2:46:36. The competition in the women's race gradually improved, featuring four sub-three-hour performances in 1974, but Gorman still blew the field away, dropping the course record to 2:47:11. (Photograph by Pamela Schuyler-Cowens, courtesy of the Sports Museum.)

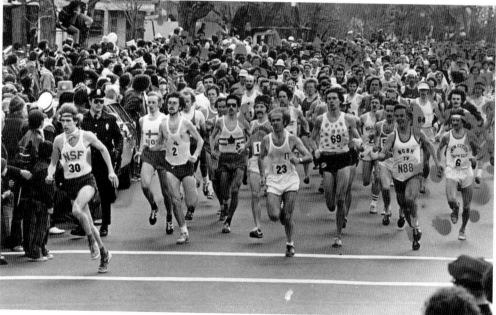

The start of the 1975 race, one of the best fields Boston has seen, included five former winners. Although not visible at the start, young Bill Rodgers was the only man at the finish a couple of hours later. (Photograph by Pamela Schuyler-Cowens, courtesy of the Sports Museum.)

Rodgers ran a blistering pace early on in the 1975 race. By the time he reached the Newton hills, he was alone enough to stop running and carefully sip some water. His break did not stop him from winning and setting a new American and course record of 2:09:55. This was the first of four Boston wins for the former teacher and Wesleyan cross-country standout. (Courtesy of the Jerry Nason Collection, the Sports Museum.)

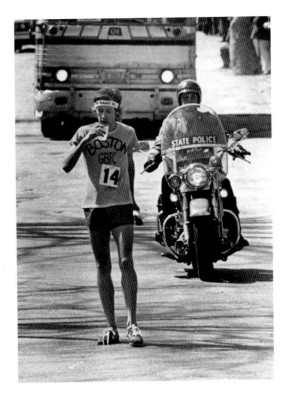

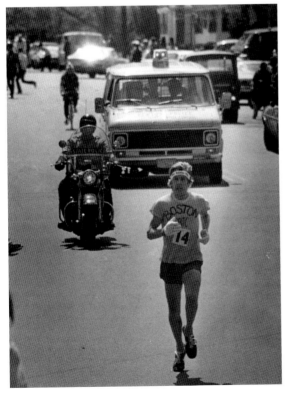

Rodgers has only the motorcade behind him as he continues to cruise through the 1975 course. Rodgers's organic look of a homemade Greater Boston Track Club t-shirt, long hair, and headband made him a crowd favorite and a perfect example of the soulful 1970s distance runner. (Courtesy of the Jerry Nason Collection, the Sports Museum.)

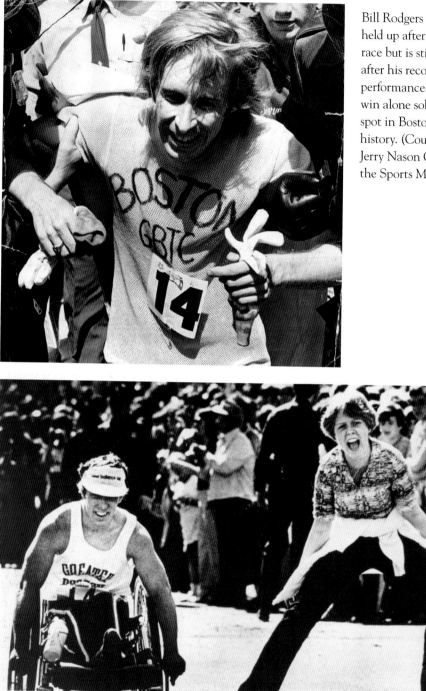

Bill Rodgers needs to be held up after finishing the race but is still all smiles after his record-setting performance. Rodgers' first win alone solidified his spot in Boston Marathon history. (Courtesy of the Jerry Nason Collection, the Sports Museum.)

Bob Hall, who did shorter races before and made a modified racing wheelchair, is cheered on by his sister during the 1975 marathon. He finished two minutes below the milestone three-hour time and more importantly furthered mobility-impaired athletes' participation at Boston. (Courtesy of Bob Hall.)

FROM 1970 TO 1990

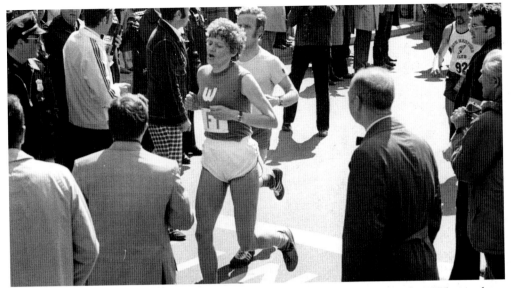

West German Liane Winter led the race the entire way en route to winning the 1975 marathon. In stark contrast to the previous year's winner, Michiko Gorman, who weighed less than 100 pounds, Winter stood at 5 foot 9 inches and weighed 145 pounds. Her size did not stop her from setting a new world record of 2:42:24. (Courtesy of the Jerry Nason Collection, the Sports Museum.)

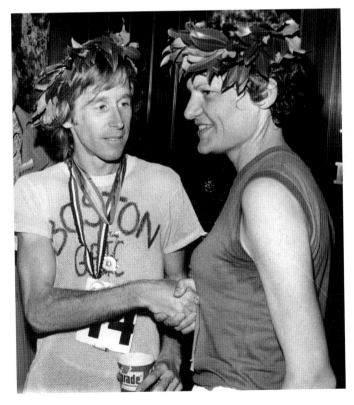

The two 1975 champions, Rodgers and Winter, congratulate each other after the race. They both set course records; Rodgers set the American record, and Winter topped him with a world record. Their performances marked a great day for all the competitors, with Boston feeling the effect of the running boom. The 1975 race had nearly 900 finishers break three hours, including Harry Cordellos, a blind runner competing for San Francisco's famed Dolphin Club. (Courtesy of the Jerry Nason Collection, the Sports Museum.)

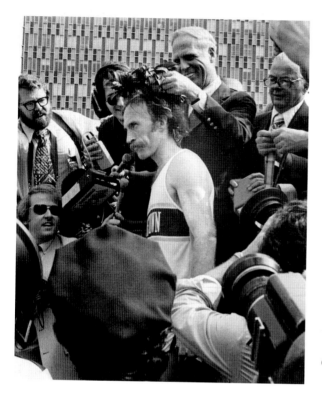

Georgetown University graduate Jack Fultz accepts the laurel crown for the infamous 1976 "Run for the Hoses." The 1976 race turned out to be the hottest day in the history of the Boston Marathon. With temperatures reaching 100 degrees, many racers remained at home. The time trials for the U.S. Olympic marathon team were to be held one month later, so most of the top Americans were out of the running. Fultz wanted to be at the trials but had not reached the sub-two hour 20 minute qualifying time. Despite his heroic win at Boston, the victory still left him 19 seconds shy of the elusive Olympic trials standard. (Courtesy of the Jerry Nason Collection, the Sports Museum.)

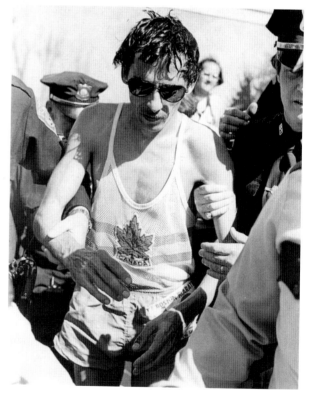

Jerome Drayton had endured temperatures in the 80s and no official water stops to win his first Boston in 1977. Initially challenged by Bill Rodgers, the Canadian pushed on, and Rodgers dropped out due to the heat. Following his victory, the enigmatic Drayton criticized B.A.A. race organizers. According to Drayton, the race was handled unprofessionally, and water was not provided for all the runners. The Boston press reacted harshly to Drayton, and he did not return the following year to defend his title. (Courtesy of the Boston Herald.)

FROM 1970 TO 1990

Frank Shorter, the 1972 Olympic marathon champion, checks his watch in the 1978 Boston race, an effort that left him eight minutes and two seconds behind Rodgers, who won his second Boston Marathon. Shorter, the king of American distance running, joined the long string of Olympic champions who fell short in Boston. Both he and Rodgers had the distinction of helping lead American distance running into the brave new world of professionalism. Both men also owned running stores and managed lines of sportswear. (Courtesy of the Boston Herald.)

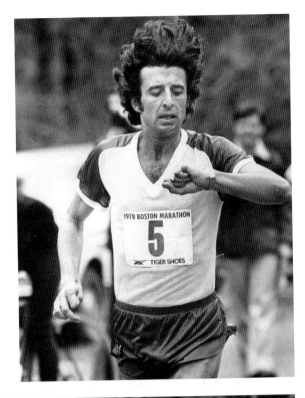

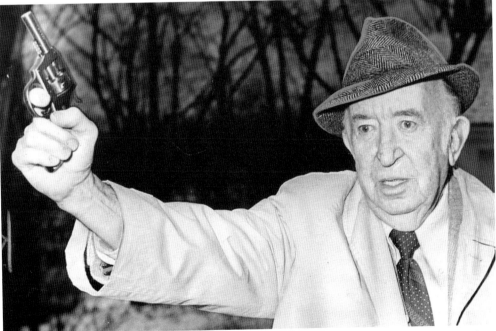

George V. Brown Jr., son of the first Boston Marathon director and brother of Boston Celtics founder Walter Brown, honors a family tradition by shooting off the starting gun in 1979. (Courtesy of the Boston Herald.)

Hometown boy Bill Rodgers breaks the finishing tape of the 1979 race, with all of Boston looking on. It was his third victory and the middle year in his three-year sweep of Boston from 1978 to 1980, a feat he shares with fellow Melrose resident Clarence DeMar. Thanks in large part to Rodgers, the running boom inspired Pres. Jimmy Carter to start running road races, and he even invited Rodgers to the White House for a state dinner. (Courtesy of the Jerry Nason Collection, the Sports Museum.)

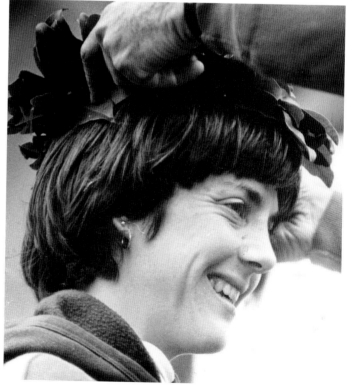

Joan Benoit is awarded a deserving olive crown after her amazing 1979 race. Benoit, a native of Maine, captured the crowd with her Red Sox baseball cap and Bowdoin College singlet. She was talented but thought to be a long shot to win, and most experts agreed that Bostonian Patti Lyons would take her home race. But Benoit ran harder than anyone expected, getting the win, the course record, and the American record, all on one rainy day. (Courtesy of the Boston Herald.)

FROM 1970 TO 1990

Jacqueline Gareau, winner of the women's marathon in 1980, lowered the course record to 2:34:28 and beat out Patti Lyons, who finished second in two consecutive years. This was not the reception she received on marathon Monday but an honorary ceremony the following Wednesday. Gareau was the first women's finisher, but fraud Rosie Ruiz entered the race late and fooled everyone, including race officials. Upon further inspection, Ruiz did not look the part of a marathon champion and could not answer simple questions about training. Ruiz was caught, and Gareau was rewarded, but still the elation of receiving the trophy and crown on race day was taken from her. (Courtesy of the Boston Herald.)

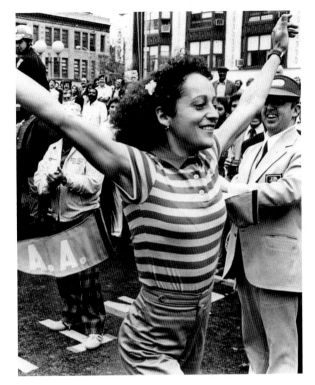

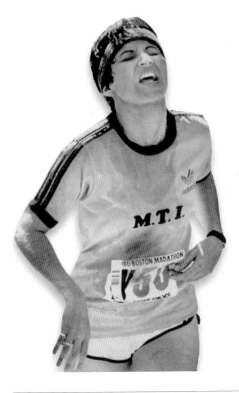

The infamous Rosie Ruiz feigns the fatigue of winning the Boston Marathon. The late-arriver had everyone tricked enough to get the victor's medal and olive crown. It was not until an interview in which Ruiz asked what an interval was and the observations about her lacking a runner's physique that the dots connected, and she was rightly condemned. (Courtesy of the Boston Herald.)

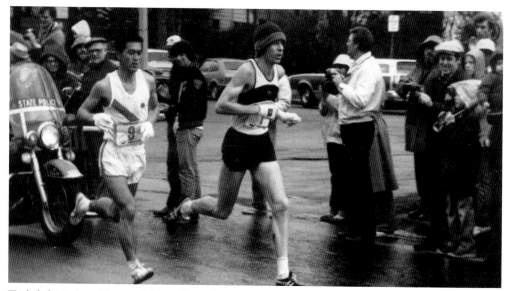

Toshihiko Seko of Japan (left) sticks with returning champ Bill Rodgers, who was aiming for his fourth win in a row in 1981. Seko was able to shake off Rodgers and beat his course record by one second. Bill dropped to third place with a time of 2:10:34, an effort which no doubt would have won many Boston Marathons, but came against an extraordinarily talented field. (Courtesy of the Boston Herald.)

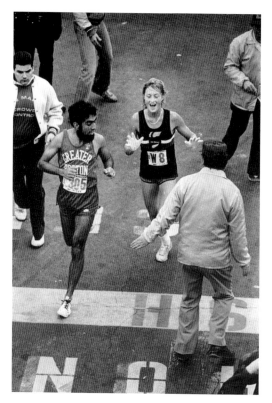

Allison Roe finishes the 1981 race with obvious joy in the knowledge that she shattered the previous record by seven minutes 42 seconds, with a time of 2:26:46. The New Zealander upset favored Americans Patti Catalano and Joan Benoit, winning the race in a slow starting, calculated manner. Although Catalano set the American record that day, she was obviously upset with second place and cried in the company of her sisters after the race. The bearded man finishing right in front of Roe is Tom Derderian, an accomplished runner, who later established himself as the chief historian of the Boston Marathon. (Courtesy of the Boston Herald.)

Former Oregon all-American Alberto Salazar survives his 1982 battle with Dick Beardsley and comes in barely two seconds ahead of him for the course record of 2:08:52. The courage and strength shown by Salazar and Beardsley all the way to the finish line leads most to regard this as the best Boston Marathon ever. Both runners paid a huge price as the result of their effort and were never the same following this epic race. (Courtesy of the Boston Herald.)

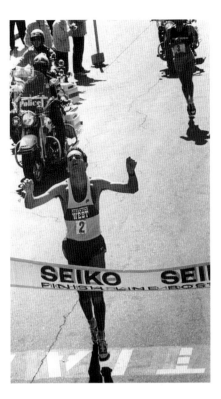

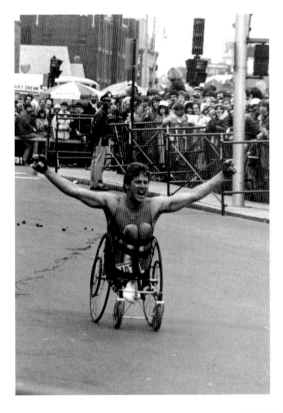

Jim Knaub crosses the finish of the 1983 race, lowering his own world record by over three minutes to 1:47:10. Knaub went on to break the world record again in the distance. Wheelchair racing at Boston started when injured Vietnam veteran and former high school runner Eugene Roberts made his way along with the runners in 1970. Not long after allowing women to race, B.A.A. officials no longer excluded any willing participants and made the wheelchair race a sanctioned category of the event. (Courtesy of the Honeywell Archive, the Sports Museum.)

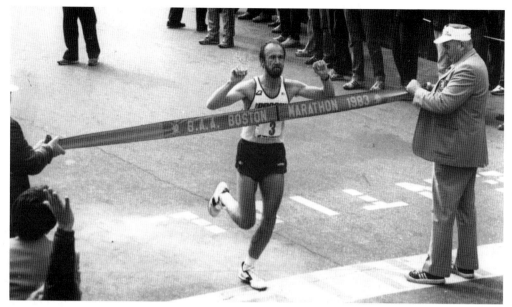

Michigan native Greg Meyer wins the 1983 marathon with a time of 2:09:00, just eight seconds off the course record set the previous year by Alberto Salazar. Meyer remains the last American male to win the Boston Marathon. At the time, such a distinction would have seemed unimaginable as America was producing some of the best runners in the world. (Courtesy of the Honeywell Archive, the Sports Museum.)

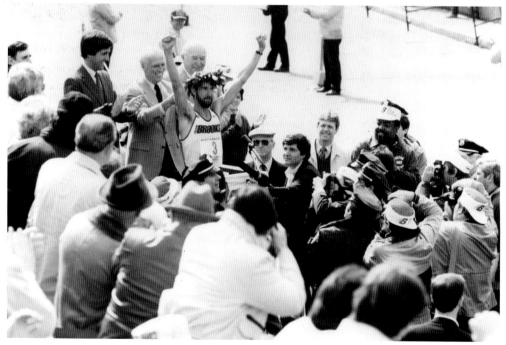

Meyer, the 1983 champion, raises his arms in victory as he is crowned with the ceremonial olive crown. (Courtesy of the Honeywell Archive, the Sports Museum.)

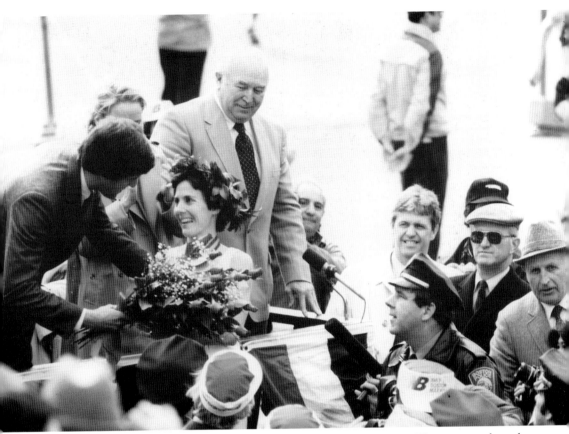

Joan Benoit is congratulated with flowers after her historic win in 1983. The race was hyped to be a battle between Benoit and favorite Allison Roe, who won two years earlier, setting the course record. One of them was expected to break some kind of record, but no one thought it would be all one sided. Roe's running was cursed by her fame and beauty. With sponsors and media after her, she had less time to train, and her natural talent could only carry her so far. After 17 miles with Benoit nowhere in sight, Roe called it quits on the race, the pressure to win getting the best of her. Up ahead, Benoit continued to pound out the miles and ran an incredible 2:22:43, a course, American, and world record. No woman had ever run as well as Benoit did that day. (Courtesy of the Honeywell Archive, the Sports Museum.)

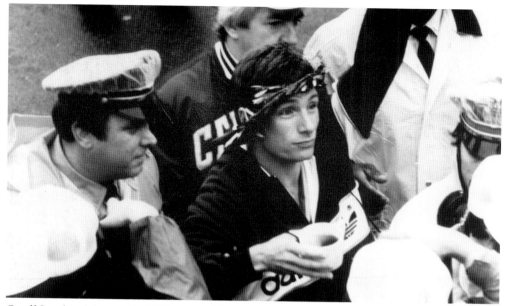

Geoff Smith celebrates his 1984 victory. He ran a smart race and did not push himself too hard in the final miles after realizing he was going to win. He clocked in at 2:10:34, an impressive time for a windy day with little competition. (Courtesy of the Honeywell Archive, the Sports Museum.)

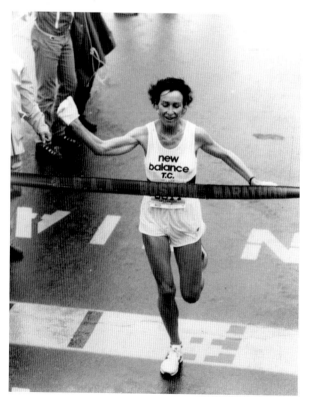

Lorraine Moller pumps her fist as she crosses the finish line in a time of 2:29:28 to win the 1984 race. Her win was especially sweet, as she had beaten her friend, prerace favorite and fellow Kiwi Allison Roe. Roe, the 1981 champion, returned to Boston with hopes winning only to drop out after 24 miles. (Courtesy of the Honeywell Archive, the Sports Museum.)

FROM 1970 TO 1990

John A. Kelley smiles as he is being escorted after a sub-five hour finish at the age of 74. Kelley's dedication to the Boston Marathon will likely never be seen again, but his active lifestyle throughout his 70s and 80s is being duplicated more and more by older athletes today. (Courtesy of the Jerry Nason Collection, the Sports Museum.)

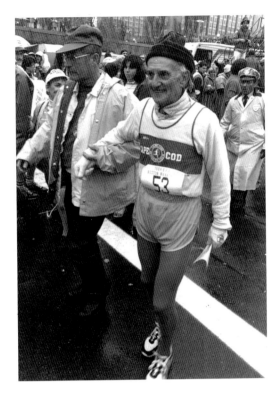

State senator Joseph Timilty (left) and Boston mayor Ray Flynn exchange greetings at the finish line of the 1984 race. Both men were avid runners and never missed a photo opportunity. (Courtesy of the Honeywell Archive, the Sports Museum.)

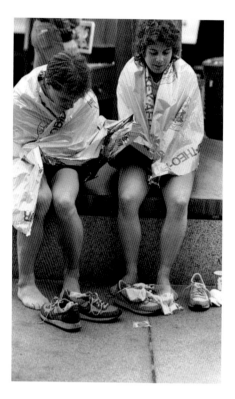

Two runners talk during their after-race recovery in 1985, huddled in Kelvalite blankets and letting their worn feet out of their shoes. These runners did not get any olive crowns or trophies, but they finished their Boston Marathon and continued in the spirit and will of the amateur runners before them. (Courtesy of the Honeywell Archive, the Sports Museum.)

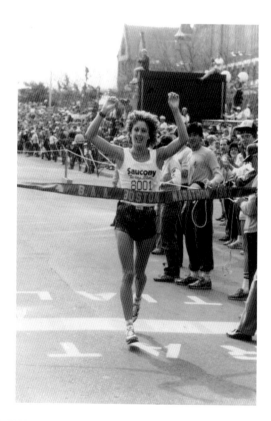

Lisa Larsen Weidenbach breaks the tape of the 1985 marathon. The Michigan native and Massachusetts resident won the race in the slowest time since 1980 with a 2:34:06 performance, almost 12 minutes behind Joan Benoit's record-breaking run two years earlier. Weidenbach was the only world-class runner in the field and received no pressure from second-place finisher Lynne Huntington, who ran a 2:42:15. (Courtesy of the Boston Herald.)

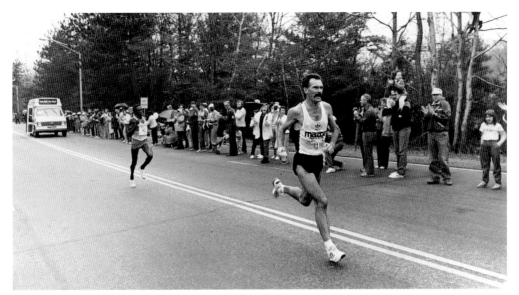

Rob de Castella powers through Framingham en route to breaking the course record with a time of 2:07:51. The Australian led the race from the start and continued to push the pace as his competition barely connected with him. He included several surges of sub-five minute miles through the Newton hills and blasted a last mile of 4:57 to establish the new record. (Courtesy of the Honeywell Archive, the Sports Museum.)

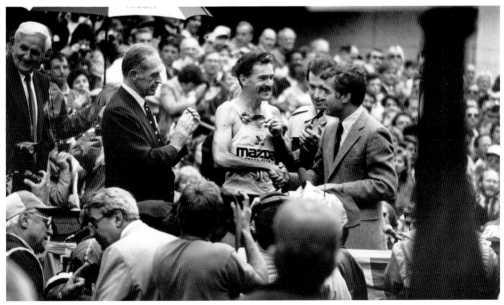

In 1986, de Castella powered his way to a course record of 2:07:51, breaking the previous one by one minute and one second. De Castella cranked up the pace at the end even though no one was in pursuit of him and also set records for all the checkpoints from mile 20 on. He is awarded the winner's medal by Massachusetts governor and 1988 Democratic presidential nominee Michael Dukakis. (Courtesy of the Honeywell Archive, the Sports Museum.)

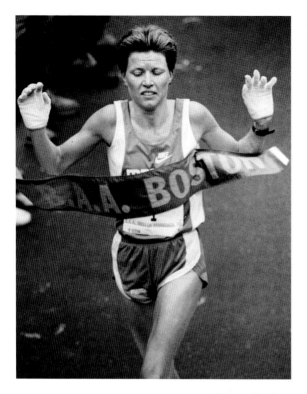

Norwegian Ingrid Kristiansen won the 1986 women's race in a time of 2:24:55, which was also good for 38th place overall. (Courtesy of the Boston Herald.)

Boston mayor Ray Flynn chats with Tanzanian runner Juma Ikangaa a few days before the 1987 race. Ikangaa went on to 11th place with a time of 2:16:17 in a race won by former champ Toshihiko Seko of Japan. Ikangaa never won at Boston, but he was one of the first world-class runners to come across the Atlantic Ocean from Africa to race. Since then, African runners have dominated distance events throughout the world, and each year, they leave a mark on the roads from Hopkinton to Boston. (Courtesy of the Boston Herald.)

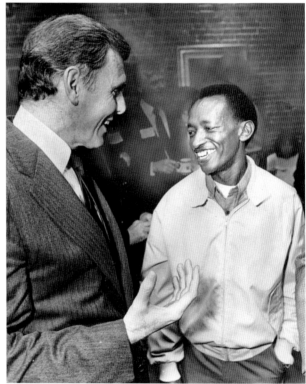

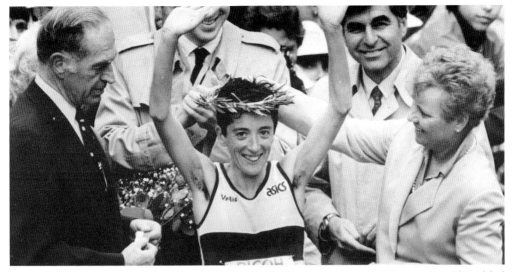

Rosa Mota of Portugal receives the laurel crown in 1987, the first of her three wins. She added the Boston victory to her bronze medal from the 1984 Olympic marathon. Her time, 2:25:21, blew away the women's field but also put her in 40th place overall, including the men's race. Although she ran an outstanding race, her time compared to the men was more a reflection of the lack of male competition than an incredible performance herself, which was almost two and a half minutes behind Joan Benoit's course record. (Courtesy of the Boston Herald.)

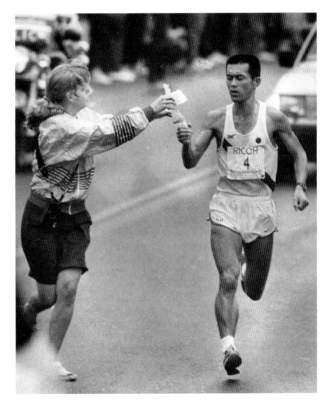

Toshihiko Seko captured his second Boston crown in 1987 with a time of 2:11:50 to beat Welshman Steve Jones by nearly a minute. (Courtesy of the Boston Herald.)

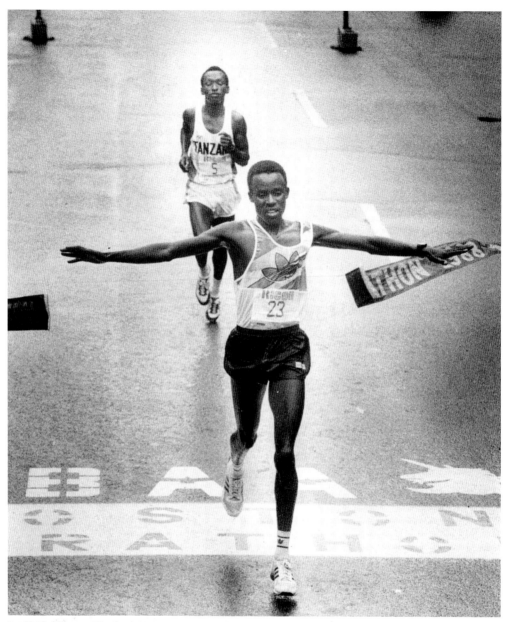

In 1988, Kenyan Ibrahim Hussein crosses the finish line a mere second ahead of Tanzanian Juma Ikangaa in the closest finish in race history. His one minute 47 second 800-meter speed came in handy at the end of the grueling race. (Courtesy of the Boston Herald.)

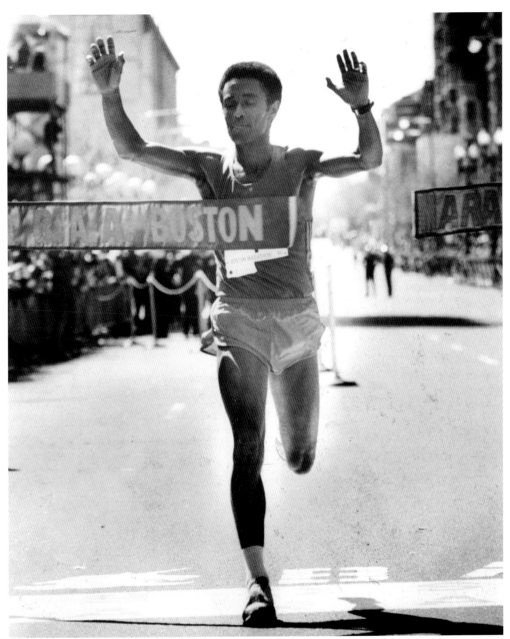

Ethiopian Abebe Mekonnen crosses the 1989 finish line in victory, following Ibrahim Hussein of Kenya as the second man from Africa to win at Boston. He beat out second-place finisher Juma Ikangaa to win with a time of 2:09:06. The first Boston Marathon of the 1980s featured hometown hero Bill Rodgers, completing his three-year sweep of the race, but it ended as a different entity. Money was never supposed to affect the B.A.A. race, but needing to draw big competition, sponsors were found, and prize money was awarded. In years past, the Boston Marathon has not seen one of its own take first place, and the overall competition has suffered, with more young runners staying with shorter distances. (Courtesy of the Boston Herald.)

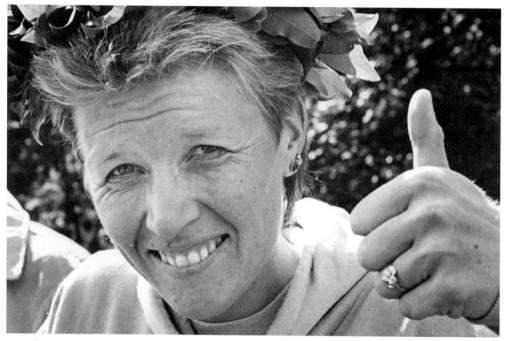

Ingrid Kristiansen gives the thumbs-up sign following a win in Boston's Bonne Bell 10-kilometer race in 1986. Her effort in the 1989 Boston Marathon also deserved a similar gesture as the she scored her second Boston triumph with a time of 2:24:33, which was also good for 26th place overall. (Courtesy of the Boston Herald.)

The decade of the 1980s brought great change to the Boston Marathon, as runners began to receive both appearance and prize money starting in 1986. The two Mercedes sedans, shown displayed near the marathon finish line, also provided incentive to the men and women's open champions. They also stood as tangible symbols of the brave new world the event had embraced with the support of corporate sponsors such as John Hancock and Adidas among others. (Courtesy of the Honeywell Archive, the Sports Museum.)

FROM 1970 TO 1990

5

FROM 1990 TO 2008

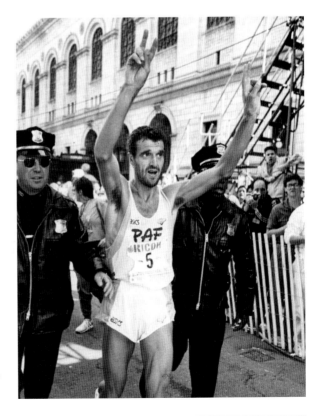

Gelindo Bordin celebrates after he won the 1990 Boston Marathon by coming back from seventh place at that half way point. Bordin, the 1988 Olympic marathon gold medalist, broke the jinx at Boston, which had never seen an Olympic champion take first place. (Courtesy of the Boston Herald.)

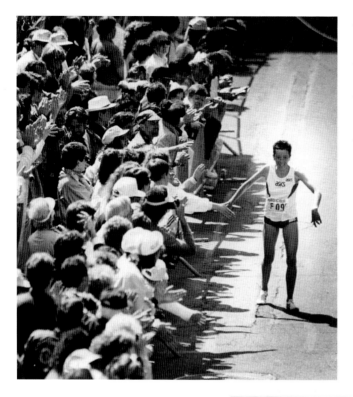

Rosa Mota of Portugal is applauded as she makes her way to her third victory at Boston in 1990. Along with Gelindo Bordin, Mota also broke the Olympic jinx. (Courtesy of the Boston Herald.)

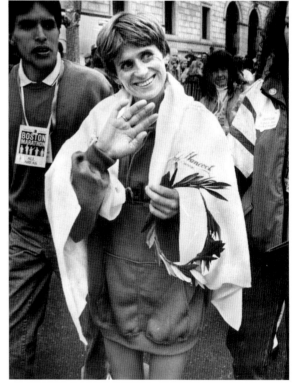

Wanda Panfil of Poland waves to the fans after she won the 1991 race in a time of 2:24:18. Panfil had a sound victory over a talented field that included past winners Joan Benoit Samuelson and Ingrid Kristiansen. (Courtesy of the Boston Herald.)

FROM 1990 TO 2008

Ibrahim Hussein, shown here winning his third Boston Marathon in 1992, became Boston's first African champion when he won for the first time in 1988. He also won the race in 1991. (Courtesy of the Boston Herald.)

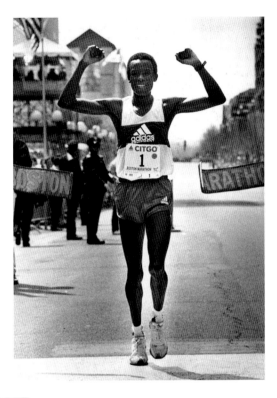

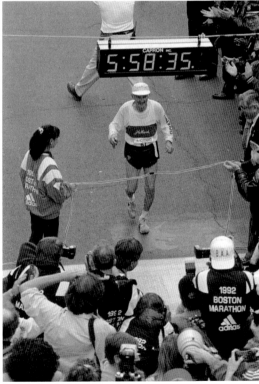

In 1992 at age 84, John A. Kelley finished his final Boston Marathon. It was his 61st Boston Marathon, capping eight decades and two victories in his beloved race. Kelley proved his dedication and athleticism by continuing to run his race at an age when most people are lucky to still be around, let alone finish a marathon. (Courtesy of the Boston Herald.)

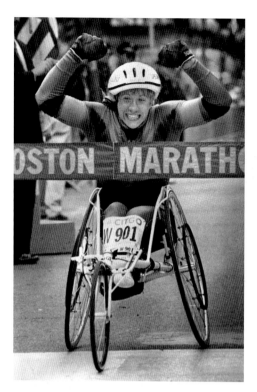

Wheelchair champion Jean Driscoll became the all-time leading Boston Marathon champion in 2000 when she captured her eighth champion's medal. Her first of seven-straight victories came in 1990 when she smashed the course record by nearly seven minutes. (Courtesy of the Boston Herald.)

On April 18, 1993, the city of Newton unveiled a one-and-a-half life size bronze sculpture depicting John A. Kelley as a both a young champion and a veteran competitor. The sculpture, titled *Young at Heart*, was a gift from noted runner Dr. Wayman Spence, who also published a book on Kelley by the same name. (Courtesy of the Boston Herald.)

Russian Olga Markova made up for the hurt she suffered after being left off the 1992 Russian Olympic team by beating countrywomen Valentina Yegorova and the rest of a deep Boston Marathon field with a time of 2:25:27. (Courtesy of the Boston Herald.)

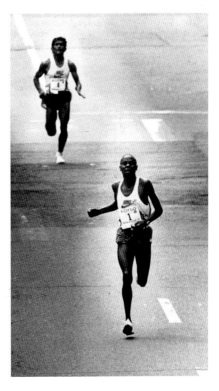

Kenyan Cosmas Ndeti captured the second of his three consecutive Boston Marathon crowns in 1994 with a course record of 2:07:15 to edge Mexico's Andres Espinosa by four seconds. (Courtesy of the Boston Herald.)

THE BOSTON MARATHON

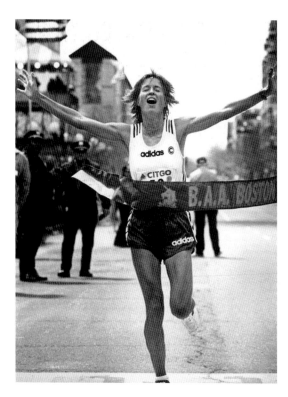

Uta Pippig is a renaissance woman. Trained as a physician in her native East Germany, she came to America following the collapse of the Soviet empire. In 1994, she captured the first of her three consecutive Boston Marathon titles with a course record-setting time of 2:21:45. (Courtesy of the Boston Herald.)

Former champions Joan Benoit Samuelson and Johnny Miles shake hands at a special reception for former champions held on the occasion of the celebration of the race's centennial in April 1996. (Courtesy of the Boston Herald.)

Boston Marathon executive director Guy Morse addresses the marathon's centennial gathering at the Fairmont Copley Plaza Hotel. For the past three decades, Morse, a former executive with Prudential, has overseen the greatest period of growth and sponsorship in race history. (Courtesy of the Boston Herald.)

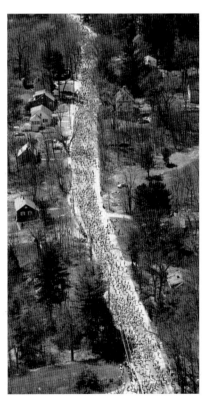

This is the 1995 Boston Marathon as viewed from an aerial perspective. Other than the move of the start from Ashland to Hopkinton, the course has changed little since 1897. (Courtesy of the Boston Herald.)

The B.A.A. invited all former living race champions to Boston in celebration of the race's centennial in 1996. This was the largest gathering of past champions in Boston's history. (Courtesy of the Boston Herald.)

The marathon centennial celebration also included the unveiling of a Boston Marathon monument in Copley Square that had the name of every champion in race history. Unveiling the monument, from left to right, are John A. Kelley, Greg Meyer, Bob Hall, Geoff Smith, Ken Lynch, Emily Talcott, Sara Mae Berman, Roberta Gibb, Jack Fultz, and Bill Rodgers. (Courtesy of the Boston Herald.)

Cosmas Ndeti, shown attempting to defend his crown in 1996, captured the 1995 race with a time of 2:09:22 to win over his fellow Kenyan Moses Tanui, who finished exactly a minute behind Ndeti. (Courtesy of the Boston Herald.)

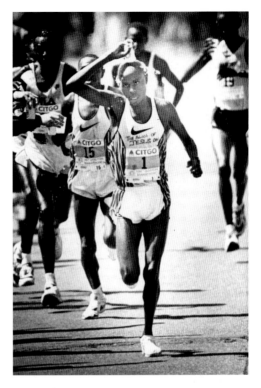

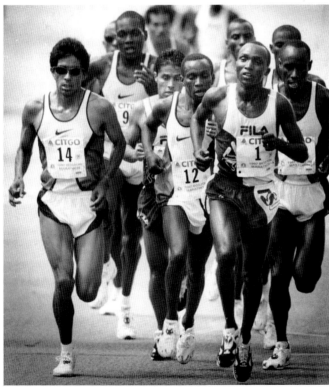

In 1996, Tanui won the centennial edition of the race while avenging his loss to Cosmas Ndeti in 1995. Tanui finished with a time of 2:09:15. (Courtesy of the Boston Herald.)

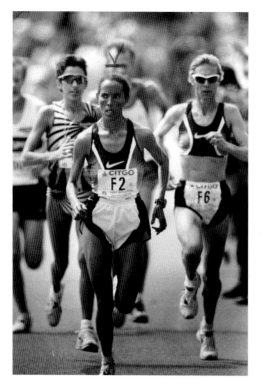

In 1997, Ethiopian Fatuma Roba won the first of her three consecutive Boston Marathons, with a time of 2:26:23. (Courtesy of the Boston Herald.)

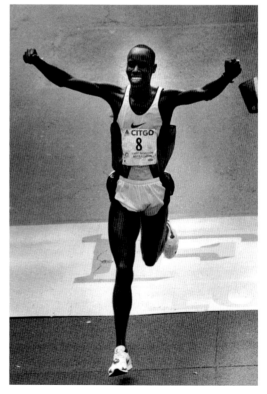

Kenyan Lameck Aguta maintained the African stranglehold on the men's open division, with a winning time of 2:10:34 in 1997. (Courtesy of the Boston Herald.)

Boston Marathon Race Director Dave McGillivray (left) has long been a fixture at the race both as a competitor (37 consecutive races as of 2008) and as a master organizer of one of the most complex sporting events on the planet. Marathon legend John "the Elder" Kelley called McGillivray "a genius" and countless runners are grateful to him for not only insuring that the Boston Marathon has flowed smoothly for over 20 years but also the many other endurance events McGillivray organizes each year. McGillivray is also famed for his many charitable acts including a legendary cross country run to benefit the Jimmy Fund in 1978 that saw the former Merrimack College cross country runner trek from Medford, Oregon, to Medford, Massachusetts, with a grand finish at Fenway Park. (Courtesy of the Boston Herald.)

In the closest-ever finish in Boston Marathon history, Kenya's Elijah Lagat beats Ethiopia's Gezahegne Abera by a stride and fellow Kenyan Tanui by two seconds, as Lagat captured his first Boston Marathon crown in 2000 with a time of 2:09:47. (Courtesy of the Boston Herald.)

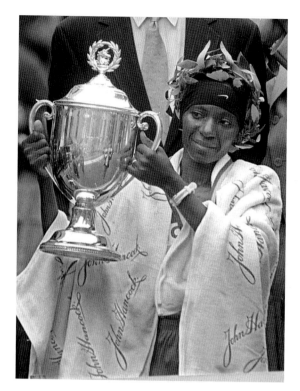

In a stunning upset, Kenya's Catherine Ndereba won the closest women's open division race in Boston Marathon history by 16 seconds with a time of 2:26:11 and broke the three-year winning streak of favorite and runner-up Fatuma Roba. Ndereba is shown on the victor's stand with part of her reward. She also won the race in 2001, 2004, and 2005. (Courtesy of the Boston Herald.)

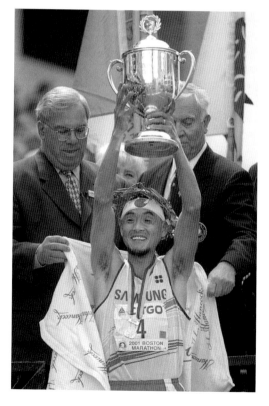

Korea's Lee Bong-Ju became the third Korean to win the men's open division when he captured the 2001 race with a time of 2:09:43. (Courtesy of the Boston Herald.)

FROM 1990 TO 2008

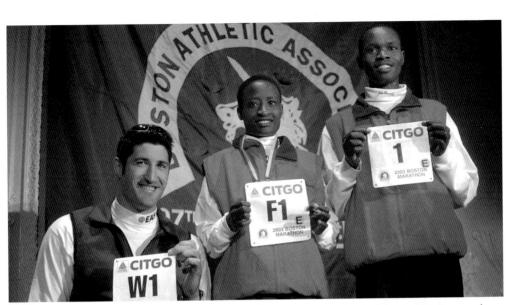

The number one race bibs are handed out to the top competitors before the 2003 marathon. From left to right, Ernst Van Dyk, Margaret Okayo, and Rodgers Rop were all back to defend their olive crowns from the previous year. Van Dyk was the only one of them to take back the title, as he did through 2006. Rop finished seventh, more than six minutes off the male champion, Robert Cheruiyot. Okayo came in fourth place. (Courtesy of the Boston Herald.)

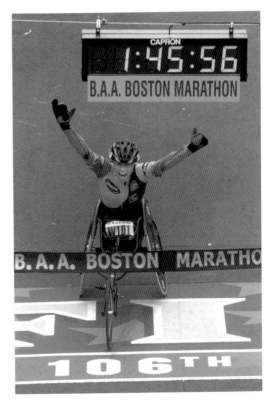

Edith Hunkeler of Switzerland captured the Boston Marathon in 2002 with a time of 1:45:57 and also won in 2006 while lowering her winning time by almost two minutes to 1:43:42. Hunkeler joined six other women, including eight-time winner Jean Driscoll, as a multiple winner of the women's wheelchair event. (Photograph by Matt Stone, courtesy of the Boston Herald.)

THE BOSTON MARATHON

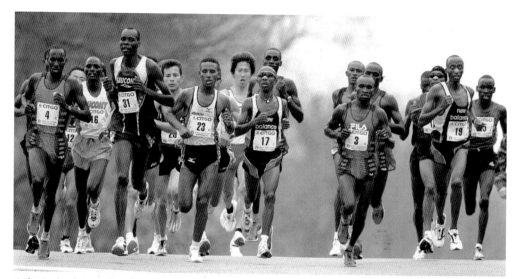

A large lead pack breaks away from the race early on in 2002. Although he is not seen here, Rodgers Rop of Kenya went on to win the race that day with a time of 2:09:02. Later that year, Rop also won the New York City Marathon, completing a sweep of the two premier marathons in the United States. (Photograph by George Martell, courtesy of the Boston Herald.)

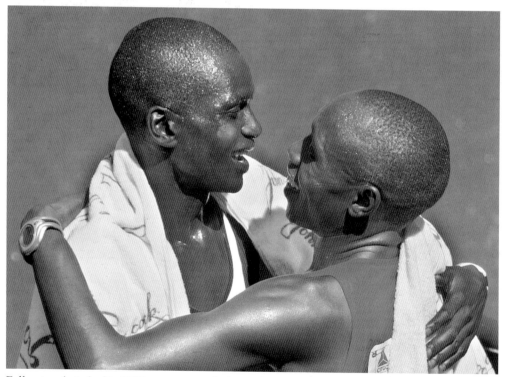

Following their duel in 2003, race winner Robert Cheruiyot of Kenya embraces fellow countryman and second-place finisher Benjamin Kosgei Kimutai, whom he had just beaten by 23 seconds. (Photograph by Matt Stone, courtesy of the Boston Herald.)

Svetlana Zakharova (F2) and the previous year's champion Margaret Okayo (F1) trade off the lead spot early in the 2003 race. Although Okayo set the course record the year before, her time had dropped nearly seven minutes, and her place had dropped to fourth. Zakharova took advantage of her rival's slip and eventually won the race in 2:25:20. She continued her successes that year, winning the Chicago marathon in the fall. (Courtesy of the Boston Herald.)

Christina Ripp of Illinois hoists the winner's trophy for the 2003 women's wheelchair division after capturing her first Boston crown in a time of 1:54:47. (Photograph by Nancy Lane, courtesy of the Boston Herald.)

Lynn Cook of West Boxford crosses the finish line on her hands after running most of the more than 26 miles of the 2003 race on her feet. (Photograph by David Goldman, courtesy of the Boston Herald.)

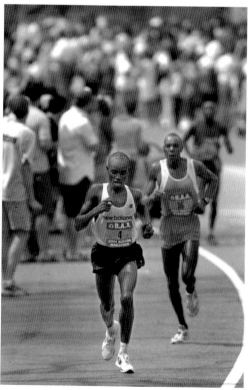

Timothy Cherigat (4) puts his head down and pushes his way through the Newton hills with Robert Cheboror (16), a fellow Kenyan, in pursuit. Cherigat held on to win the 2004 race with a time of 2:10:37. He came in fourth place at Boston the year before but was able to win in 2004 due in part to temperatures reaching the high 80s, which slowed down the lead pack. (Photograph by Kuni Takahashi, courtesy of the Boston Herald.)

FROM 1990 TO 2008

Heartbreak Hill has been the scene of countless duels over the past century, including this battle in 2004 between Kenyans, from left to right, Rodgers Rop, Cherborer, Cherigat, and Martin Lel. Cherigat eventually broke from the pack to win the race. (Photograph by Kuni Takahashi, courtesy of the Boston Herald.)

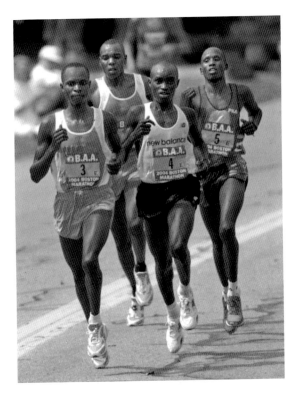

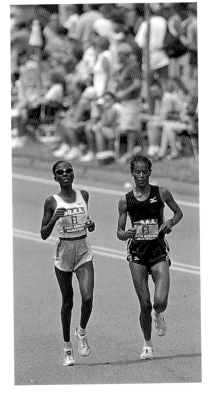

Catherine Ndereba (F1) and Elfenesh Alemu (F3) battle down Commonwealth Avenue in Newton, leading the race by about three minutes through the final miles in 2004. Ndereba was able to out kick Alemu and go on to win her third Boston Marathon. (Photograph by John Wilcox, courtesy of the Boston Herald.)

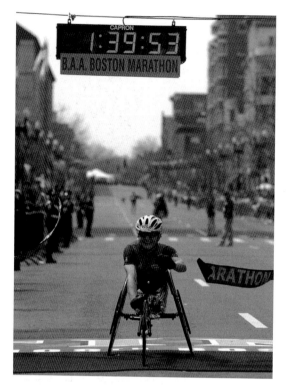

Cheri Blauwet breaks the tape as the first female finisher in the wheelchair division in 2004. Blauwet was coming off a breakthrough year in which she won both the Los Angeles and New York marathons. She continued her success in Athens at the Paralympic Games, earning a gold medal in the 800-meter event along with two bronzes in the 5,000 meters and the marathon. (Photograph by David Goldman, courtesy of the Boston Herald.)

One of the delights of the Boston Marathon are the spontaneous displays of silliness, such as the puckish nationalism shown by Angus Treloar, a citizen of Australia living in Brookline, Massachusetts, at the time, crossing the finish of the 2004 race with an inflatable friend from down under. (Photograph by Tara Bricking, courtesy of the Boston Herald.)

FROM 1990 TO 2008

Dick (above) and Rick Hoyt cross the line in the 2004 marathon. Together they are team Hoyt, a father and son who compete together in races and triathlons in hopes of including the physically challenged in everyday life. Rick was born as a spastic quadriplegic with cerebral palsy. His disability did not stop him from graduating from Boston University and being an equal race partner with his father. Their accomplishments include 26 Boston Marathons in which they have become a fixture. (Photograph by Tara Bricking, courtesy of the Boston Herald.)

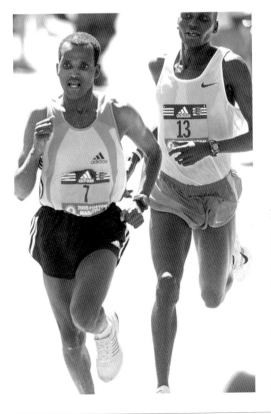

Hailu Negussie (7) takes Robert Cheruiyot (13), the 2003 champ, as they finish up Heartbreak Hill. Negussie did not look back and went on to win the 2005 race. Negussie, an Ethiopian, was one of the two male runners to break Kenya's winning streak dating back to 1991, the other runner was Korea's Lee Bong-Ju in 2001. The following year, he dropped out of the race, unable to defend his title. (Photograph by Michael Seamans, courtesy of the Boston Herald.).

Waves of runners make the final push to the finish near Kenmore Square. The giant Citgo sign of Fenway Park fame is also a close marker for the 25th mile. This part of the race is undoubtedly a highlight for every runner, finally with the certainty that they will finish the race and the opportunity to enjoy the final minutes of it. (Photograph by Faith Ninivaggi, courtesy of the Boston Herald.)

Running a marathon is not just about the few hours of the actual event but also the hundreds of hours of training, stretching, and icing. It is about the personal sacrifices and the commitment to a goal, a New Year's resolution, a childhood dream, or even a country's hopes. The Boston Marathon is host to a unique field of the fastest amateur and professional runners in the world, all of whom know the importance of crossing that finish line on Boylston Street, whether by sprinting, walking, or crawling across it. (Courtesy of the Boston Herald.)

Mackenzie Carrol of Hopkinton directs cars and runners to the Olsen family driveway on Hayden Rowe Street, where they can "park & pee." The fee for parking is $15, while the bathroom door is open at no charge. (Courtesy of the Boston Herald.)

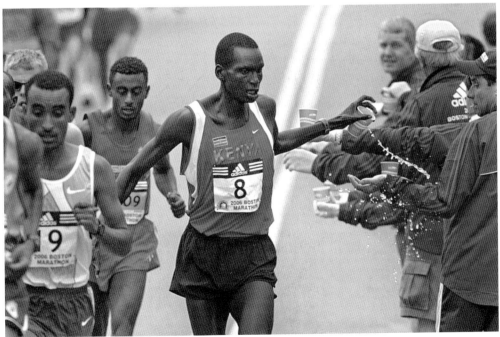

Robert Cheruiyot (8) grabs a cup of water early in the race en route to his second Boston win and a course record time of 2:07:14, lowering the one set by fellow Kenyan Cosmas Ndeti in 1994 by one second. (Photograph by David Goldman, courtesy of the Boston Herald.)

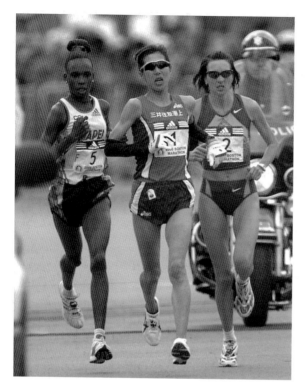

The top three women finishers in the 2006 race battle towards the finish, vying for first place. Rita Jeptoo (5) won the battle and the race with a time of 2:23:38, edging out Jelena Prokopcuka (2) of Latvia by 10 seconds. Reiko Tosa (1) of Japan came in third, 33 seconds off first place. Jeptoo, along with men's winner Robert Cheruiyot, completed a Kenyan sweep of the open races at Boston in 2006. (Photograph by Ted Fitzgerald, courtesy of the Boston Herald.)

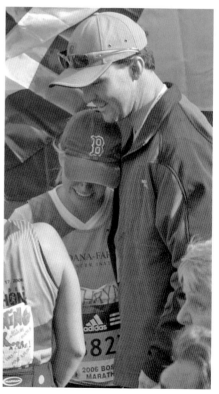

Red Sox outfielder Trot Nixon comforts his wife, Kathryn, after she finished the marathon in a very respectable 3:49:20 in 2006. Kathryn was raising money for the Jimmy Fund along with other Red Sox wives, including Mike Timlin's. The Jimmy Fund is an organization that works with the Red Sox to help raise money for cancer research and care for children battling cancer. (Photograph by Nancy Lane, courtesy of the Boston Herald.)

FROM 1990 TO 2008

Stephen Biwott (12) and Cheruiyot (1), both Kenyans, run in the lead past excited fans, who made it out despite temperatures in the 40s and rain. The harsh weather affected the times, and Cheruiyot was able to win in 2:14:33 in 2007, his third Boston win and second in a row. Biwott faded to 11th place, but he rounded out Kenya's dominance as their eighth finisher in the top 11 spots along with the first four finishers. (Photograph by David Goldman, courtesy of the Boston Herald.)

In 2007, one of the coldest, rawest days in Boston Marathon memory, Lidiya Grigoryeva (6) of Russia was able to grind out a win. The weather turned the marathon into a real "guts race," as the late Steve Prefontaine might have said, and a lot of heart was on display throughout the race. Grigoryeva's winning time of 2:29:18 was the slowest winning time since 1985, but she still managed to put away Jelena Prokopcuka (2) by 40 seconds. (Photograph by Tim Correira, courtesy of the Boston Herald.)

Bob Adams receives multiple high fives from the women of Wellesley College near the half-way point of the 2008 race. (Photograph by Angela Rowlings, courtesy of the Boston Herald.)

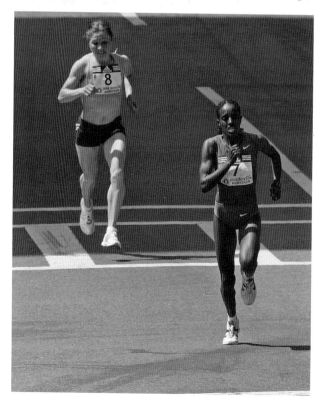

The finish of the 2008 women's race was reminiscent of the classic 1982 race with Alberto Salazar and Dick Beardsley and will surely be remembered in the same regard. Dire Tune (7) of Ethiopia traded surges with Alektina Biktimirova (8) of Russia throughout the last half mile until Tune was able to find one final kick and win the race by two seconds, the closest finish ever in the women's race and the same as the 1982 men's finish. (Photograph by Nancy Lane, courtesy of the Boston Herald.)

FROM 1990 TO 2008

Wakako Tsuchida holds the winner's trophy after capturing the women's wheelchair division of the 111th running of the race in 2007. (Photograph by Nancy Lane, courtesy of the Boston Herald.)

John A. Kelley, joined by B.A.A. governor Gloria Ratti, tips his cap to the fans at the finish line of the 2004 race. Kelley was coming to the finish line of his own life but not before 97 years, 61 Boston Marathons, and two olive crowns. Kelley ran his last Boston Marathon in 1992 at the remarkable age of 84 and enjoyed his last Boston appearance. (Photograph by Tara Bricking, courtesy of the Boston Herald.)

DISCOVER THOUSANDS OF LOCAL HISTORY BOOKS FEATURING MILLIONS OF VINTAGE IMAGES

Arcadia Publishing, the leading local history publisher in the United States, is committed to making history accessible and meaningful through publishing books that celebrate and preserve the heritage of America's people and places.

Find more books like this at
www.arcadiapublishing.com

Search for your hometown history, your old stomping grounds, and even your favorite sports team.

Consistent with our mission to preserve history on a local level, this book was printed in South Carolina on American-made paper and manufactured entirely in the United States. Products carrying the accredited Forest Stewardship Council (FSC) label are printed on 100 percent FSC-certified paper.

MADE IN THE USA